ART ON A STRING

ABORIGINAL THREADED OBJECTS FROM THE CENTRAL DESERT AND ARNHEM LAND

Louise Hamby and Diana Young

Co-published by Object–Australian Centre for Craft and Design
and the Centre for Cross-Cultural Research

Elsie Marmanga, detail of six necklaces all containing red bead tree seeds threaded on fishing line, 2001.

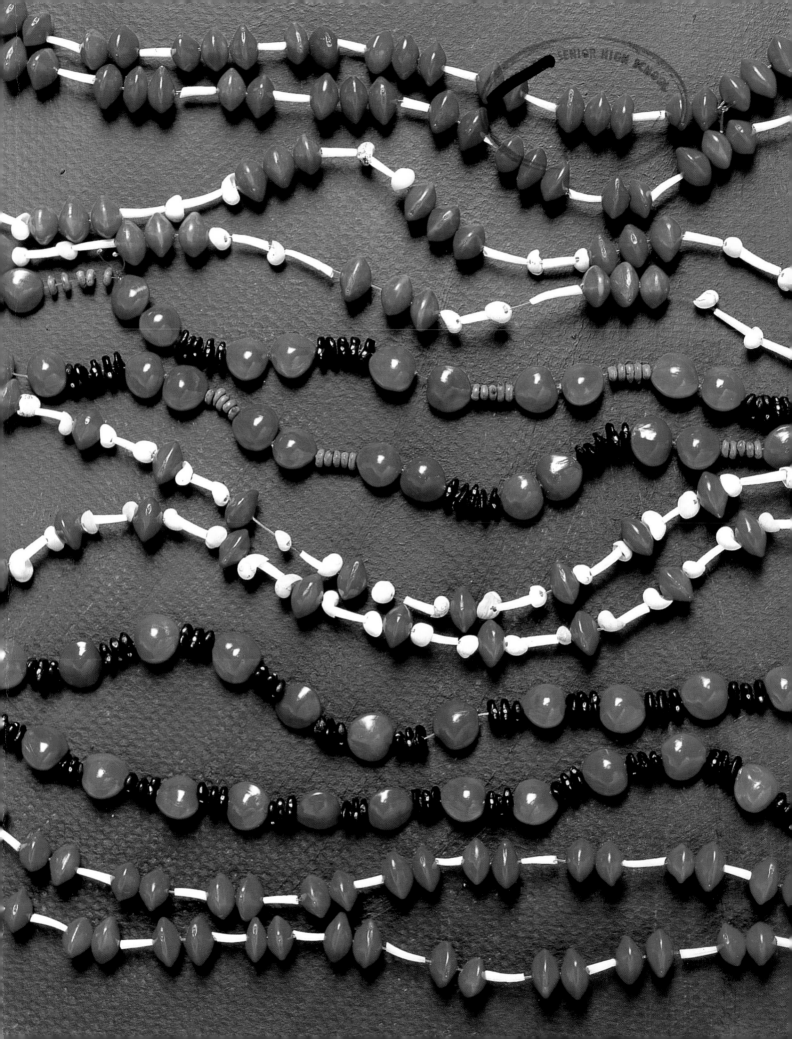

Co-published by Object–Australian Centre for Craft and Design and the Centre for Cross-Cultural Research to accompany the exhibition *Art on a String, Threaded Objects from the Central Desert and Arnhem Land*, Object galleries 13 October – 2 December 2001 then touring nationally.

Curators: Louise Hamby and Diana Young
Editors: Nicole Bearman, Ian Were (Object) and Sylvia Kleinert (CCR)
Art Direction: Stephen Goddard
Design: Imogen Landau
Printing: Lamb Print, Perth, Western Australia

Studio photography (full-page images and catalogue section): Russell Pell
Documentary and support photography: Louise Hamby and Diana Young unless otherwise stated

ISBN 0 957 8180 6 8

This exhibition is supported by Visions of Australia. Visions of Australia is the Commonwealth's national touring exhibitions grant program. It assists with the development or touring of cultural exhibitions across Australia.

This project has been assisted by the Commonwealth Government through the Australia Council, its arts funding and advisory body.

The project was also assisted through research funding from Chelsea College of Art and Design, London and the College of Fine Arts, Sydney to support Diana Young and Louise Hamby respectively.

The project has also received support from the Andrew Thyne Reid Charitable Trust.

Front cover: Eileen Watson, detail of necklace, 2001, acrylic painted gum fruits and bat-winged coral seeds threaded on string. Photo: Russell Pell
Back cover: Djupuduwuy Guyula, Lucy Ashley and Anna Malibirr, detail of painted and unpainted grass stem necklaces, 2000. Photo: Russell Pell

object
australian centre for craft and design

the centre for cross-cultural research
AN AUSTRALIAN RESEARCH COUNCIL SPECIAL RESEARCH CENTRE
THE AUSTRALIAN NATIONAL UNIVERSITY, CANBERRA, ACT 0200

Australia Council
for the Arts

Visions
of Australia

ANDREW THYNE REID
CHARITABLE TRUST

CONTENTS

FOREWORD

THIS CATALOGUE, AND THE ASSOCIATED EXHIBITION, IS DESIGNED TO INTRODUCE AUDIENCES TO THE AESTHETIC and symbolic power of necklaces and other strung objects made by women and men from Arnhem Land and the Central Desert. The catalogue and exhibition will draw attention to contemporary works that have previously been neglected and to arts and craftspeople whose achievements have gone unrecognised. The works, made with seeds, shells and bones, for example, provide a testimony to Indigenous knowledge of the environment and to the Indigenous perceptions of the properties and potentials of natural forms, their texture, smell, sheen as well as shape. All of those associated with this project sincerely hope that the result will be an increased awareness of, and sensitivity to, the craft and design achievements of Indigenous Australians.

The curators of this exhibition, Louise Hamby and Diana Young both have backgrounds in art practice as well as a breadth of relevant academic and curatorial knowledge. Louise has recently completed a doctorate at the Australian National University that examined the function, form and manufacture of fibre forms in eastern Arnhem Land and continues to lecture undergraduates at the College of Fine Arts, University of NSW. Louise also holds a Visiting Fellowship at the CCR (Centre for Cross-Cultural Research). Diana Young completed her doctorate in anthropology at University College, London, on the role of colour and the senses in the region of Ernabella in Central Australia. She lectures on material culture and spatial theory at Chelsea College of Art and Design in London.

The catalogue, exhibition and collaboration with Object are of great significance for the CCR. This activity furthers our goals to encourage aesthetic dialogue between cultures and the mutual appreciation of artistic practice and to ensure that we develop fruitful working relationships with galleries, such as Object, as a means of extending research into the public domain.

Object provides an ideal partner for the CCR in this enterprise as it shares our aspiration to establish links between Indigenous artists, cultural centres and national cultural institutions. We are extremely grateful to Object for the opportunity this project has provided the CCR to meet its objectives.

We are also grateful for the support of the Australia Council. A grant from the Visual Arts/Craft Fund provided financial assistance for the production of this catalogue.

Professor Howard Morphy
Director, Centre for Cross-Cultural Research, Australian National University

T HE *ART ON A STRING* PROJECT IS AN EXCITING AND IMPORTANT ONE FOR OBJECT–AUSTRALIAN CENTRE FOR CRAFT and Design. This publication and the travelling exhibition of the same name break new ground in the research and promotion of contemporary Aboriginal art, craft and design practice.

The threaded and beaded objects, which have been so beautifully photographed for this catalogue, speak elegantly and powerfully for themselves and their makers. Object's core mission is to significantly increase the visibility and viability of contemporary craft and design in Australia. We hope that the *Art on a String* project leads to an increased appreciation of the beauty and importance of this work and also to an improved position in the marketplace for it.

I would like to congratulate the curators, Louise Hamby and Diana Young, on their tireless research and their thoughtful selection of extraordinary necklaces, bracelets, curtains and other objects made by Indigenous artists from the Central Desert and Arnhem Land. Louise and Diana's commitment, tenacity and hard work have enabled us to produce an outstanding exhibition and accompanying publication. When they approached us at the end of 1999 with the outline of this project, they had already undertaken extensive fieldwork research and had spent months developing and refining the ideas. The project seemed well suited to our aims and from early in 2000 they worked with Associate Director, Brian Parkes and other key staff from our Exhibitions and Publications programs. The result is one we are all very proud of.

Art on a String has provided Object with an opportunity to work with a number of diverse and dynamic organisations throughout Australia including Aboriginal art centres in the Central Desert and in Arnhem Land and all of the galleries and museums who will be presenting the exhibition. One of the most important and rewarding relationships has been our collaboration with the Australian National University's Centre for Cross-Cultural Research, with whom we have co-published this catalogue. The CCR's assistance has been crucial and we would like to especially thank Howard Morphy and Julie Gorrell for their support.

We are grateful also, for the support of Visions of Australia from whom we received a grant for the development of the exhibition and its national tour.

Steven Pozel
Director, Object–Australian Centre for Craft and Design

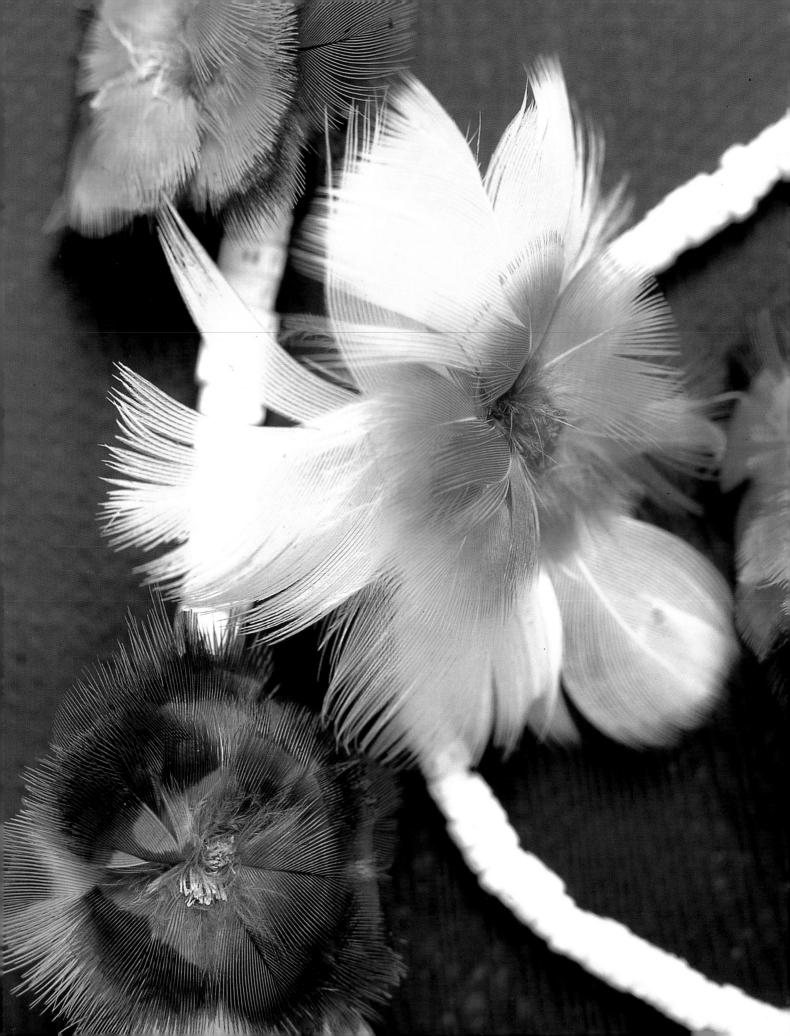

INTRODUCTION

Art on a string—life on a string

Always there in the west, the sound of it's cry...
This string is mine (says the seagull), at the place of the billabong...
String, short string, and a bird's head...
The keen eyes of the gull search for food in the night, as a lover looks for his sweetheart[1]...

The exhibition is called *Art on a String*. A fibre, a string—substance, threads, filaments, that can be spun, woven, or felted. A series of persons or things, a family lineage. A dietary material. The structure, grain or character of something. A cord for tying or holding things together. If stone tools are the beginnings of human civilisation then the making of string must be there also. To fix these stone tools to handles and shafts, to weave, to wrap, to carry or, to sling.

The song above speaks of the practice of making wooden images of seagull's heads that are attached to feathered string, and used in love-magic. Drawing the string, pulling it away from the direction of your intended love draws their affections to you. Strings generally have a serious ritual function in this society—the sacred as well as the profane, mundane everyday usage. For practicality string is made in as long a length as one can make with the materials and time available and then used as needed. There is the story of the Morning Star that is attached to the spirit world by a string, sometimes described as a string of light reflected on the ocean's surface.

The sun's rays touch us, warming our backs
Rays like the parakeet—feathered string of our sacred poles!
Feathered string like our child![2]

Rose Mamuniny #2,
detail of necklaces
showing feathers (47
and 46), 2001.

All types of technology were given to the first human beings by the original creative spirits. On the north shores of Arnhem Land the Djang'kawu Sisters came across the ocean and then along the coast. They wore string headbands, belts, chest harnesses, and string armbands. They gave birth to the first people and taught them their language, songs, ceremonies, laws and customs. They were the first women and showed other women how to live and enjoy life. In ancient Greek religious beliefs three female deities, called the Three Graces, were the personification of grace and beauty. They stood for the three-fold aspect of generosity—giving, receiving, and returning of gifts or benefits. The Djang'kawu Sisters and the Wagilag Sisters from the north, and the Seven Sisters in the central Australian region were similar role models not only in law, but also for their grace, charm and aesthetic sensibility in what they ate, how they walked, and how they adorned themselves.

In the contemporary practice of other Aboriginal groups, feather appendages carry a range of meanings—string tassel, sacred string marking a journey, connecting landscapes, people, family lineages, the umbilical cord. Joining pragmatic art object, people, land, spirit and history in one.

In great clusters the fruits are hanging down;
Gleaming a rich yellow, the fruits are hanging down.
Gleaming a deep gold, the fruits are hanging down;
Gleaming a rich yellow, the fruits are hanging down.[3]

From earlier times to the present, Aboriginal women have kept an encyclopedic understanding of useful plants and a pharmacopoeia of natural medicines beyond those that can be used as food. These were used in day to day mundane applications, and to construct bags, fish traps and other utilitarian items which stand on their own as beautiful sculptural forms. In a sense these materials and creations were controlled by season, availability of fibre plants, seed or fruit pods. Of course in the desert this normal cycle might actually take several years to run its course.

How do we describe the beauty and place of these objects, made as much for sale as to be worn? Beauty is a combination of aesthetic qualities such as shape, colour, and so on that please the intellect or moral senses. Grace is a particular type of attractiveness defined by elegance, proportion, manner or movement. The variety and balance in colour and arrangement is stunning. What we see here is something else. Eclecticism in an art sense— the selection and drawing together of many personal styles or visual ideas. These objects are works of art.

Djon Mundine OAM

endnotes

1. RM Berndt, 'Love Songs of Arnhem Land'. Song 26, Goulburn Island Cycle, Nelson, 1976.

2. RM Berndt, *Djanggawul: An Aboriginal Religious Cult of North-Eastern Arnhem Land*, Routledge and Kegan Paul Ltd, 1952, Song 24.

3. TGH Strehlow, *Songs of Central Australia*, Angus and Robertson, 1971.

All cited in: *Australian Dreaming, 40,000 Years of Aboriginal Dreaming*, compiled and edited by Jennifer Isaacs, Ure Smith Press, Sydney, 1992.

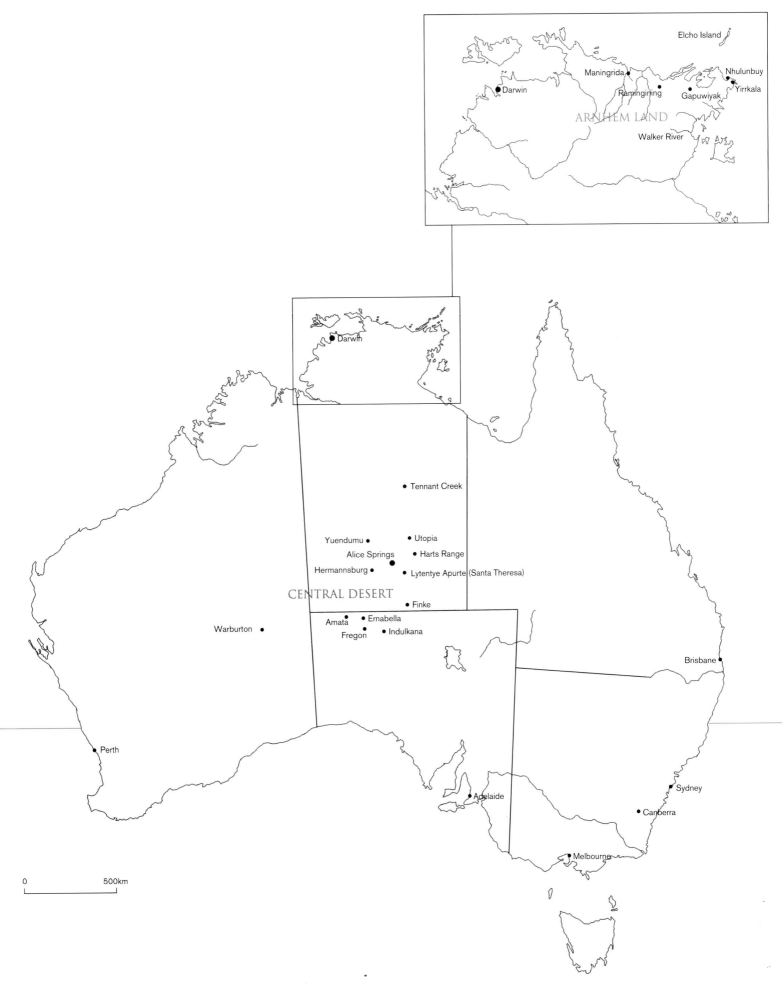

Elcho Island

Maningrida ● Nhulunbuy
Ramingining ● Yirrkala
Darwin ● Gapuwiyak
ARNHEM LAND

Walker River

Darwin ●

Tennant Creek ●

Yuendumu ● ● Utopia
Alice Springs ● ● Harts Range
Hermannsburg ● ● Lytentye Apurte (Santa Theresa)

CENTRAL DESERT

● Finke

Amata ● ● Ernabella
Warburton ● Fregon ● ● Indulkana

Brisbane ●

Perth ●

Adelaide ●

Sydney ●

Canberra ●

Melbourne ●

0 500km

11

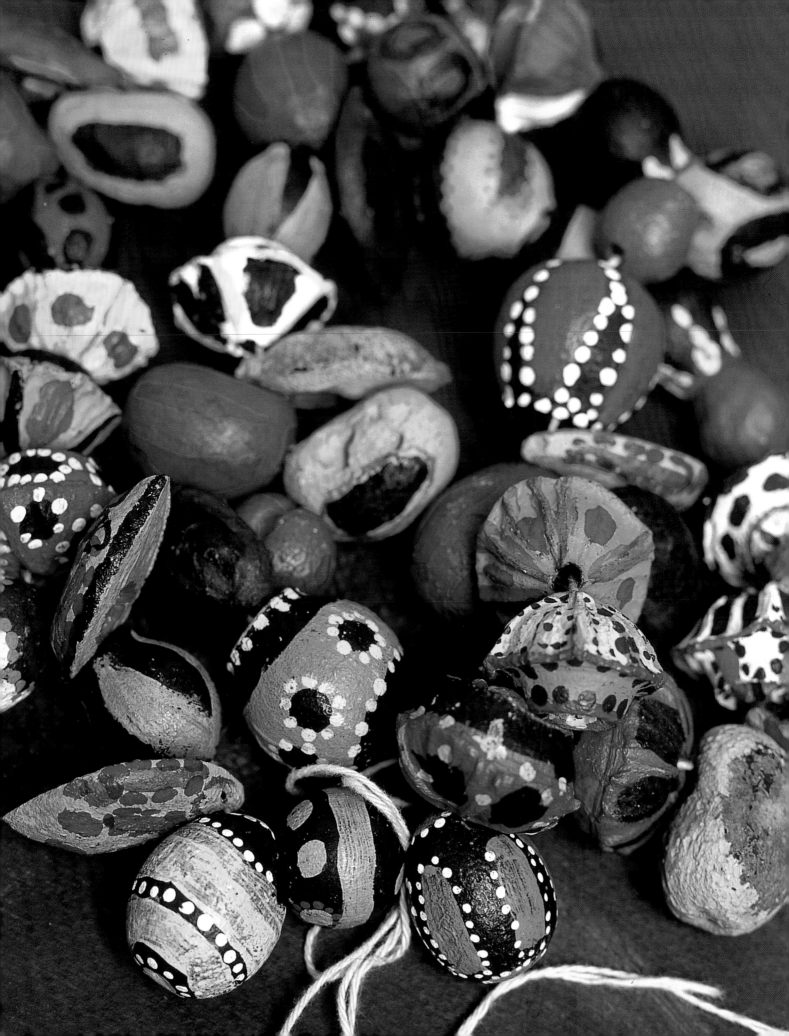

ART ON A STRING

ART ON A STRING IS THE FIRST EXHIBITION EVER TO BE DEVOTED ENTIRELY TO THE INTRICATELY COLOURED AND patterned strings made into necklaces, bracelets, wall hangings, mats and fly curtains. The list of what art on a string might be is limited only by the makers' imagination.

An urban-living Australian might come across such items—usually a few necklaces—hanging in a shop or gallery in Sydney or Alice Springs with a low price tag attached and no sign of the maker's name. In these circumstances one would have no inkling of the innovation and creativity involved, the hours of painstaking work required to make the piece and its connection to country.

The artists participating in *Art on a String* come from twenty-three Aboriginal cultures across the two separate regions of the Central Desert and Arnhem Land.[1] The show was conceived with the support of some groups of artists from these two regions. There were other artists who received news of the show with delight and incredulity; "Don't you want paintings?" they asked, amazed that their necklace making should be of any interest to a gallery. Women in Arnhem Land were happy that someone wanted to talk about and exhibit their work. In Maningrida, Betty Ngurabanguraba instructed, "You should write it down!"

This response is born of experience. Art on a string is often dismissed as tourist art or 'kitsch' and retailed for a meagre amount of dollars. The artists often receive much less. Considering this poor rate of return it is surprising that women, for it is almost entirely women who make this work (there is one male artist in this exhibition) still devote their time to this activity. Few community art centres buy necklaces or other string pieces from the producers on a regular basis, so work is often sold direct to shops, anonymously, by the artists themselves for an immediate return. To identify individual makers and styles requires time and additional effort from wholesale buyers. Some art advisers in Aboriginal communities and retailers elsewhere are aware of this problem and are seeking means to address it.

Aboriginal art practices vary greatly from community to community in both Arnhem Land and the Central Desert areas, but the practice of seed and string work, especially necklaces, is widespread throughout both. Many of the makers are highly successful contemporary artists in media more valued by the art market—including acrylic painting on canvas, bark painting, batik, and printmaking—and have work placed in major Australian,

Eva Napananka Kelly,
detail of painting in necklace
(20), 1999.

Japanese, European and American art collections. The painter Bessie Liddle and well-known batik artist and painter Daisy (Nyukana) Baker both have works in *Art on a String* and are both inveterate bead makers. Lena Kuriniya from Maningrida in Arnhem Land is famous for her prints and sculpture for example and Gulumbu Yunupingu is known as an established bark painter. Other artists in this show concentrate on necklace or other bead and string work and have never had their work shown before. Both Elsie Marmanga and Mabel Anka-anaburra are primarily necklace makers and have never had their work shown. Leonie Campbell's consummately crafted necklaces, Martha Palmer's woven bat-winged coral seed (or bean tree seeds) *Erythrina Verspertilio* necklaces and Maudie Raggatt's family tradition of mat making with bat-winged coral seed are also examples of work that has never been exhibited.

Although few would now question an Aboriginal artist's right to work in say acrylics on canvas, less generosity is afforded to work in other media. The market into which these works are sold uses one set of criteria to judge 'non-western' art and another to judge 'western' art[2]. The question of ties to past practices and of what is deemed 'authentic' is often still used as criteria for buying or exhibiting Aboriginal art. Such misunderstanding has made art on a string almost invisible in gallery contexts. Although art on a string can be appreciated for its aesthetic qualities alone, because it has been neglected as a facet of Aboriginal art practice, it is necessary to contextualise the work within a wider cultural arena.

The Desert and Arnhem Land represent two of the most diverse geographical regions of Australia. In Arnhem Land many of the artists live on the coast or on islands giving them easy access to the animals from the sea and shells in abundance. In the Desert the red of the land, accentuated by an intense blue sky, is transformed after rains into green, and in the months following bursts of colour from flowers. In the Top End of the Northern Territory, the dominant colours of the country are blues and greens. Some of the Desert plants, which can survive with little water, are not found in the Top End. *Art on a String* presents the diversity of work from the Desert and Arnhem Land linked to the environments of the makers but also strives to point out the shared links between people. What are not apparent from looking at the work are the kin relationships that exist between Arnhem Land and the Desert by way of marriage. Men from Arnhem Land sometimes have wives from the Desert and vice versa. There is a great deal of movement between the two parts of the country. For example, in 2001 children were visiting Elcho Island, the home of their father, but they normally lived in Alice Springs. Ideas and materials travel with the women who move back and forth. However, there are also strong cultural preferences for certain materials. Snail shells of a similar appearance to those used in Arnhem Land are found in the Western Desert, but artists there expressed surprise at seeing them made into art on a string.

Panoramic view of a beach, Elcho Island, 2001.

Dirt road after rain, Musgrave Ranges, near Ernabella, Anangu Pitjantjatjara Lands, South Australia, 1997.

Daisy (Myukana) Baker, detail of Fly curtain (85), 2001.

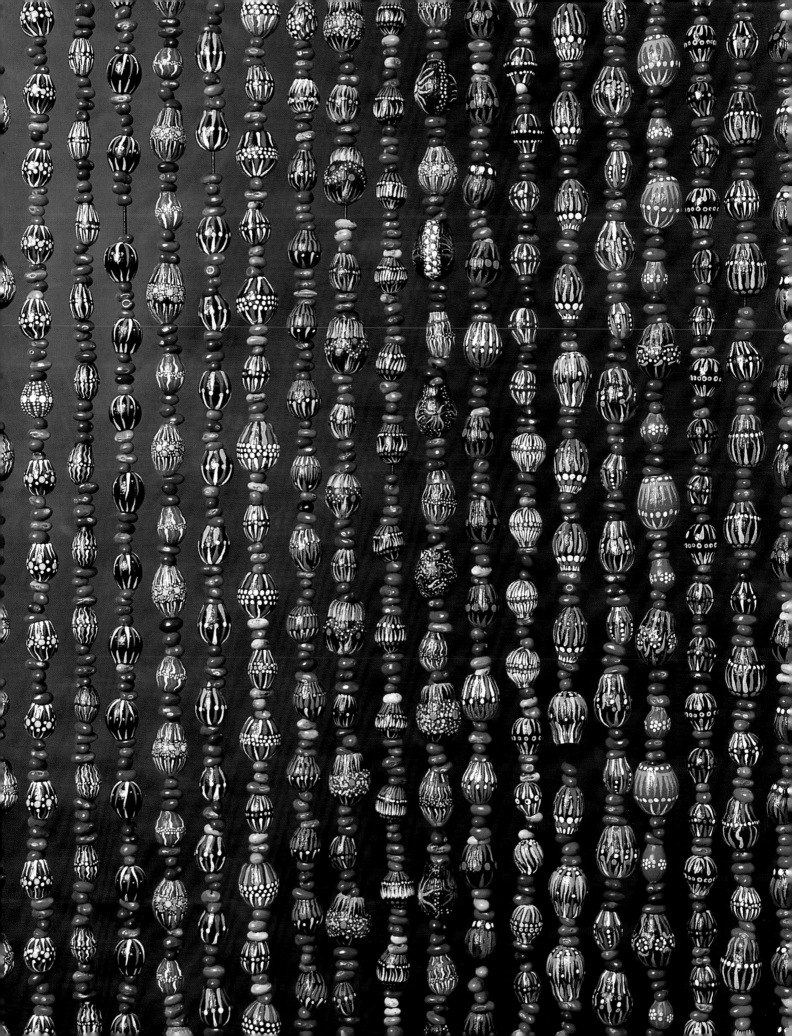

String was, and continues to be, a most important item in many Aboriginal societies. Hand-spun from plant fibres, human hair, fur and in Arnhem Land with feathers added, string is considered to materially bind people together, manifesting and mediating their relatedness to one another and to the land. String is used in love magic to attract a lover. String is used to connect family members to one another and to disconnect them from someone who dies. It is also used for religious purposes 'stringing' together places marked by the ancestral dreamings as they walked the earth during the Dreaming. The tracks of an ancestor made as she moved through country link the sites as a sequential string of places. Thus string as an artefact has many meanings adhering to it; motion and attachment, rapidity and binding.

In Arnhem Land the ancestral shark *māna* is particularly important for Dhuwa people.[3] The shark is often depicted towing the sacred string/rope line *Bundhamarr*. This line unravels as the shark swims it through saltwater country connecting groups of people. Historically, the vertebrae of this powerful animal have been used to make necklaces. The majority of these were left white but in some cases they were rubbed with red ochre as in the older necklace from the 1930s (pictured) that belonged to one of the daughters of the famous Yolgnu leader Wonngo. It is important that the shark is represented in *Art on a String*. The following interview explains the ownership and importance of shark in ceremony to Arnhem Land people. Rose Mamuniny #2 is a Gälpu woman, one of the owners of shark.

Shark

Date: May 4, 2001, People: Rose Mamuniny #2 and Louise Hamby, Place: Galiwin'ku, Setting: At the Art Centre

LH This special *māna* (shark) one

M Special *muka. Djambarrpuyngu Djapu nhäkur Guyula Djambarrpuyngu dhuwal bala different Djambarrpuyngu ga nhäpuy be nha waripum Däṯi'wuy Ngaymil Gälpu. Dhuwali limurru ḏar'ḏaryun dhuwali limmurung.*
It is indeed special. For Djambarrpuyngu–Guyula and other Djambarrpuyngu groups–for Djapu, and for others Daṯi'wuy, Ngaymil Gälpu. We sing this one, this one is ours.

LH So only these people?

M *Dhawarr'yuna ga bunggul walal djäma mäṉagur.*
That's the lot, they are the ones who are holding/owning the ceremony for shark.

Artist Unknown, An ochred shark vertebrae necklace that belonged to one of Wonngo's daughters, c1935, The Donald Thomson Collection, On loan to Museum Victoria from The University of Melbourne.

To imagine a place is to recall it in relation to its connection with others and to those adjacent along its track. The track an ancestor left between places is not necessarily a straight line. Lightning and rainbows are sky tracks of colour and brightness and are especially potent manifestations of ancestral power connecting the sky and the earth.[4]

Items made from string were the only garments worn by Aboriginal people in central Australia before contact with colonisers. Necklets, belts, breast pieces, pubic tassels and ochred umbilical chords were worn.[5] In section 4, some of the artists in Gapuwiyak recall the wearing of beaded string breast pieces. But while contemporary threaded pieces made to sell are usually construed by outsiders as body wear, there is often no such specificity in the creator's mind. Desert artists mention making art on a string for themselves as wall hangings. The fly curtains for windows and doors featured in the exhibition are an extension of this.

There is always the linkage of the body to land as exemplified in the paintings by central Australian artists of 'bush necklaces' as creek beds in section 3 of this book. However, many of the artists in this exhibition have designed pieces which are meant to sit on the body in a certain way, especially pendants or strings of symmetrically paired beads. Necklaces and bracelets are called 'for the neck' or 'for the arm' in many languages, but these are generic terms and 'necklace' is not necessarily the defining characteristic of a work. String pieces are also made for the sound they produce, for example the rattle of the snail shells in this exhibition.

As anthropologists Spencer and Gillen recorded in the 1890s, Central Desert women of the Arrernte who lived, and continue to live, on the land that became Alice Springs wore threaded seeds as necklaces.[6] Spencer and Gillen endowed many museums in Australia and Britain with long strings of human hair threaded with bat-winged coral. The seeds are recorded in some of the museum's accession records, as 'red' or 'yellow' but all have become brown with age. Indeed in certain conditions bat-winged coral seeds loose their brightness quickly, suggesting perhaps they were intended to be fleeting, ephemeral in their effect. Hair string is also susceptible to damage from feeding insects occupying the seeds strung on it.

Among Pitjantjatjara women and children and their western neighbours the Naanyatjarra, gum fruits and other seeds, *tjinytjulu*, were worn woven into hair fringed around the face. The portrait of Anne Jack, now a schoolteacher in Amata, shows her wearing green seeds threaded into her blonde hair. This style, which also helped keep the numerous and persistent small flies of the Australian bush out of the wearer's eyes, was worn

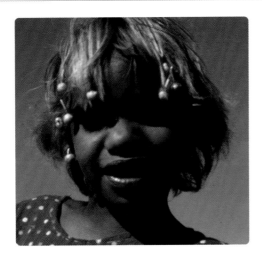

Anne Jack with *tjinytjulu* [seeds] probably from the umbrella bush, in her hair. Amata late 1960s. Photo: Noel and Phyl Wallace collection, Ara Irititja Archive.

until the late 1960s. The link to the contemporary fly curtains of painted gum fruits strung on leather, named by Daisy Baker as *punpunpaku (punpunpa/*fly *ku/*belonging to or about in Pitjantjatjara) becomes obvious.

Contemporary beaded string art works are an extension of all these past forms, taking new materials—acrylic paints, tiny glass beads that resemble seeds, white plastic that resembles shells, wooden beads that resemble gum fruits, knitting wool that is faster, better hair string—and combining them with traditional materials still yielded by the land. String also has metaphorical resonances in the connections between people and land, land and sky, present day humans and the ancestral dimension.

Like many non-Aboriginal women working in Aboriginal communities, the curators of this show were given necklaces as gifts. Artists also give necklaces to each other, which can later be converted into cash. Inherent in giving a necklace as a gift is perhaps the intention of literally stringing together the maker and the recipient. This metaphor rings true even more in Arnhem Land where fishing reels are used to store the string. A string will reel you in.

It is through this network of Aboriginal friends and contacts that the idea for this exhibition was born and most of the pieces in the show came from these artists. It would of course be possible to find 100 exquisite pieces of art on a string in shops but then the possibility of ever finding out who made them would be remote. As outsiders we would know nothing of the artist, of their individual style, the characteristic way of tying a knot in the string, of their design painted on the gum fruits, or the combination of red and white shells and seeds that other artists know that they habitually use. There are many individuals and many genres of work that could not be included here but which we hope may form the catalyst for future shows with other artists and curators.

In the following sections we look towards establishing a critical framework for art on a string. In section 2 we concentrate on the formal properties of the works in the show. Their intertwined colour, rhythm, pattern and odour, the style of individual artists and the possibility of identifying local styles of work are discussed, something considered as standard for painting or textile art.

In section 3, the materials chosen and their place in country is explored at a time when women are always seeking ways to be on the land, in their own country, but also to travel more

widely and frequently throughout Australia. The attendance of Christian services by Desert people in Arnhem Land has consequently widened the distance that raw materials travel. Collecting materials for necklaces, like finding food from the land, is an excuse to be away from communities and out in the bush again. Ownership of certain sites that yield materials for necklaces is discussed.

The making of the finished beaded string, during which artists in both regions consider 'raw' materials to become 'cooked', including the time consuming drying and burning processes to pierce or open the seeds and shells, is the subject of section 4.

endnotes

1. Arnhem Land: Anabara Burarra, Burarra, D̲äṯiwuy, Djambarrpuyngu, Djapu, Gälpu, Ganalbingu, Golumala, Gumatj, Kunwinjku, Ḻiyagalawumirr, Nakarra, Ndjébbana, Ritharrngu, Wagilag, Waramirri; central Australia: Warlpiri, Luritja, Western Arrernte, Eastern Arrernte, Pitjantjatjara, Yankunytjatjara, Naanyatjarra. In some Aboriginal languages some consonants are underlined to denote a retroflex.

2. H Morphy, 1995 'Aboriginal Art in a Global Context' in D Miller (Ed), *Worlds Apart,* Routledge, pp.211-239.

3. In north-east Arnhem Land everyone and everything is divided into two groups or moieties. They are known as Dhuwa and Yirritja. Groups of people often known as clans are also Dhuwa or Yirritja. Aboriginal people living in north-east Arnhem Land are called Yolngu and the block of languages spoken by them as Yolngu-matha, however the people who live in the Maningrida area are not called Yolngu but identified by their individual groups like Nakarra or Burarra.

4. DB Rose, 1992, *Dingo Makes Us Human: Life and Land in an Australian Aboriginal Culture,* Cambridge University Press pp.94-96.

5. CP Mountford, Unpublished journal of an expedition to the north west of South Australia, 1940, State Library of South Australia.

6. "Amongst the younger women especially, ...there maybe worn a long string of the bright red beads of the bean tree. Each bead is bored through with a fire stick, and the pretty necklet, thus made hangs around the neck in several coils, or may pass from shoulder to shoulder under the opposite armpit", WB Spencer and FJ Gillen, *1899 Native Tribes of Central Australia*, MacMillan and Co, New York, p.27.

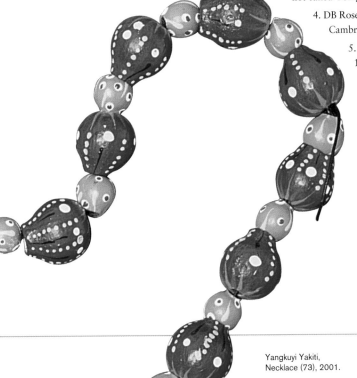

Yangkuyi Yakiti,
Necklace (73), 2001.

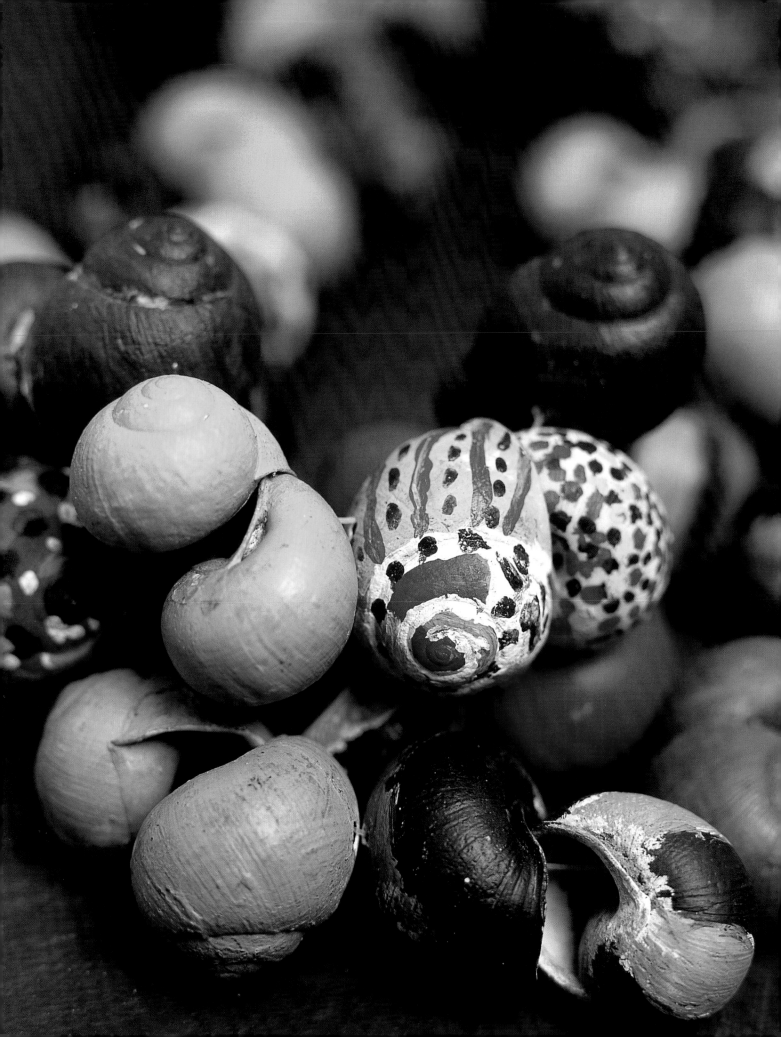

COLOUR AND RHYTHM

A ALL THE WORK IN *ART ON A STRING* IS COMPOSED OF SMALL POINTS OF COLOUR ARRANGED IN RHYTHMIC groups. The contrast between colours and their repetition or difference is crucial to the effectiveness of each piece. Artists resident in Arnhem Land or the Central Desert, who make art on a string, have these same formal criteria in common, even if the materials they are using differ. This section is about some of the formal structures of rhythmic colour and pattern that artists use to make their work.

● COLOURS

Colours—often as bright and as shiny and contrasting as possible—are a necessary part of contemporary Aboriginal societies in central Australia and in Arnhem Land. People have used coloured modern things—clothes and acrylic paints for example—to create a new kind of aesthetic, building on and elaborating those of the past. In the traditions of western culture, colour is regarded as superficial, a thin surface layer on things, that is not really worth attending to. In Aboriginal cultures it is precisely this quality that makes colour so powerful with its ability to change things. Bright colour makes things powerful and dynamic; the red ranges of the Western Desert that the light changes to pinks and purples at sunset and sunrise, also shifts them in and out of the foreground as they change colour. The surface of the land changes with rain or fire, which in turn make new green growth and flowers. Fat (from animals such as the kangaroo, emu and various lizards) and ochres change the skin colour of human bodies and paint applied to canvas or to seed beads, are linked to the central concept of transformation in Aboriginal peoples' religion. That ancestors could change 'skins' during their time walking the earth in the Dreaming, is indexical of their power. A series of colours may relate to the same person or thing or ancestor in a different time, place or incarnation.

In Arnhem Land there is more choice of colour and pattern in naturally occurring materials suitable for necklaces —highly patterned shells—and iridescent blue, pink or orange ones, for example. The availability of acrylic paints has enabled artists in the Desert to apply intricate coloured patterns to larger seeds such as gum fruits. As in other artwork produced here, artists seek out more and more brilliant colours, fluorescent and metallic car paints, to obtain the effect that they want. Outsiders, including art advisers, have attempted to influence the way

Lucy Ashley and Anna
Malibirr, detail of painting in
necklace (42), 1999.

that Aboriginal artists have used colour in art made for the market.[1] This has happened less with art on a string. These works have fetched so little in monetary terms that focus has been more on the functionality of threading materials, although there are some markets that still specify unpainted or poker-worked gum fruits believing that these are more 'authentic'. Threading materials are often the subject of edicts by art advisers who buy the work and are responding to retailers. In the Desert especially, the work of freelance makers is thus characterised by a similarly free use of colour in threading materials. As well as brown or black wool that look like hair-string, bright blue, green, red, yellow and violet knitting wools appear as flashes of colour in the slack between the beads. Similarly red knitting wool is mostly used in place of red ochred hair string for ceremonial headbands in many places in the Western Desert and artists are certainly equating the two.

Many of the groupings of work in *Art on a String* are arranged by colour. In both Arnhem Land and the Western Desert, artists seek out naturally occurring red seeds. In the Western Desert the seeds of the bat-winged coral tree are a catalyst for making art on a string. The red seed 'staples' for necklaces in Arnhem Land are the red bead tree seed *Adenanthera pavonina*, and crab eye seeds *Abrus precatorius*. Artists from the Desert region have admired the red bead tree seed and use them, if they can get their hands on them, during trips to the Top End. The seed is more regular and uniformly brighter red than the bat-winged coral and occurs in a range of hues from a yellow-orange to orange to the ubiquitous deep shiny red. There are only red ones in *Art on a String*. The importance of red is common to both regions. Bright red is attractive, appearing to come forward spatially in front of other bright colours and it is also a colour that embodies ancestral power.[2] Red also expresses dangerous or unstable states, one where change is imminent. Red and white alone are a combination of colours rarely used by Western Desert artists but in Arnhem Land some artists choose to use these. The red and white group in the exhibition includes work by Elsie Marmanga, Mabel Anka-anaburra and Margaret Likanbirriwuy who have used bat-winged coral seeds or red *Abrus* seeds with white shells or shark bone. Nellie Nambayana from Maningrida using reddish Desert bat-winged coral seeds also chooses to contrast them with cream sundial shells.

Green is an unusual colour for necklaces and there are several from the Western Desert in *Art on a String*. During the years 2000 and 2001 the whole Western Desert was unusually covered in green growth from prolonged rains making it look like the tropical Top End. The green necklaces that artists were making then reflect and represent this state of the land. Kangitja Mervin's green necklace, made at this time, is also reminiscent of the flocks of green budgerigars that come with the rains, flashing green and yellow as they fly.

Kangitja Mervin,
necklace (31), 2001.

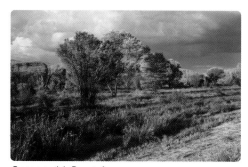

Green growth in Desert after
rain, Alice Springs, 1997.

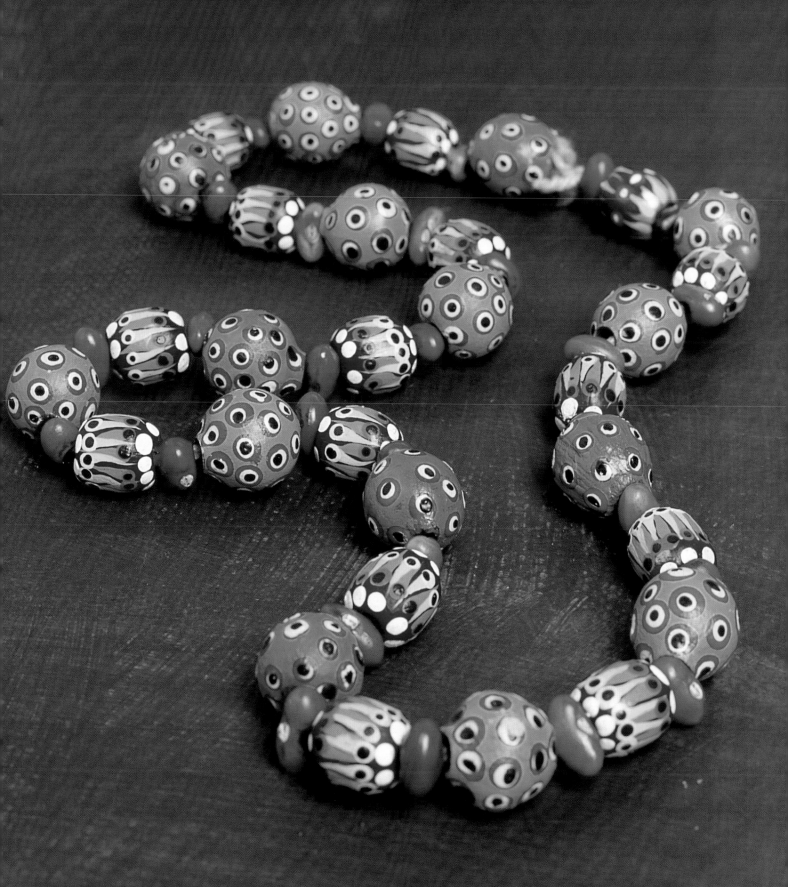

Blue has also become an important colour in both regions. In the area of the Pitjantjatjara Lands in South Australia, blue is said to be the colour of water holes reflecting the sky, and of Christianity. Yangkuyi Yakiti (73) and Betty Munti (74) whose blue necklaces are in this group, both come from the Aṉangu Pitjantjatjara Lands. The iridescent blue shell operculums from Arnhem Land in Wuyuwu Mununggur's necklace (71) were much admired by artists in Ernabella, who saw photographs of them. The purple and pinks in painted Desert works in the exhibition are much admired colours, especially together, and are often used by artists making seed beads. They are associated with sunsets and the sheets of flowers transforming grassland at certain times of the year. Eileen Watson's long string of bloodwood *Corymbia opaca* fruits is painted in a repeat pattern of splashes of yellow and magenta, the colours of the bloom mats of flowers that cover this country during the winter in rainy years. In Arnhem Land there are naturally occurring pink and mauve shells and many are used in this exhibition.

Artists use varnish or oil to enhance the colour and the contrast of colours in the materials they have chosen—an approach used in other art and craftwork. Pitjantjatjara and Yankunytjatjara people use specially chosen red and yellow timber for the wood carvings *puṉu* which then have poker-work pattern applied to their upper surfaces. The wood is finally oiled to deepen the colours and make the branded black pattern more vivid.[3] Betty Munti on painted gum fruits (27), and Agnes Petrick, on her poker-worked gum fruits, have used varnish on their work in *Art on a String*. Agnes Petrick also talks of using hair oil to make bat-winged coral seeds shine. Cooking oil might also be used as it is for rubbing into skin. Rubbing and handling of seeds and wearing them next to the skin, also adds shine. In Arnhem Land, seeds from the sea especially, like the marine drift seeds, which are dulled by their time in salt water, are cleaned and oiled to bring back their colour and shininess.

Metallic paints, like those in Panjiti McKenzie's curtain (86) and Joy McArthur's necklace (13), are also being used by artists to add shine to their work. There is an association between shine and fat for Aboriginal people in both regions. Animal fat is an important substance both to eat and to rub into a person's skin, and is a conduit of ancestral power. Shine is considered to have a tactile quality since it is associated so strongly with fat. In both regions fat is used as a carrier of colours for body painting with ochres and acrylic paint. Fat enhances colour and brings shine to surfaces, to a person's skin and also to the surface of objects such as those in *Art on a String*. The anthropologist Donald Thomson noted the relationship of bright red things and fat connected in the word *marr* in north-east Arnhem Land. Here artists choose some materials because of their natural shiny surface which reflects light back to the observer. 'Necklace shells' have a particularly reflective smooth surface. *Abrus* and the red bead tree seeds also have very hard shiny surfaces. In *Art on a String* Nyinyipuwa Guyula selected tiny shiny black glass beads to combine with the duller texture of ironwood seeds (79).

After fire the cycad palms are the first brilliant green to return to the blackened earth in Arnhem Land, 1999.

Magenta flowers of parakeelya and the yellow blossom of prickly wattle bushes, Anilalya Homelands, Aṉangu Pitjantjatjara Lands, South Australia, 1997.

The simplest of rhythms is one of constant repetition using material pierced in the same plane. Daisy Kanari's (3) necklaces of red bat-winged coral seeds are beautiful contemporary examples of strings of these seeds commonly made in the past and worn by women in central Australia.[4] In Arnhem Land, the rare orange shells picked out and strung by Beverly Barupa (1), the pairs of curved black kapok seeds by Minawala Bidingal (6) and the shark tail vertebrae graded in size by Philomena Wilson (2), all rely on the texture and colour of a single material.

Duncan Lynch began making necklaces in 2001 to show the different colours of the seeds from a tree, which he said was 'like a gum tree', on his homeland north of Alice Springs. His work exploits the transformation of colour in one material. Unusually he used the green seeds and pointed out the 'dry brown ones' contrasting with them. Duncan Lynch then went on to make necklaces (5, 30 and 32) using different colours of gum flower cases and attached bud caps or 'operculums', red ones and green ones, from another gum tree. Green seeds are seldom used in necklace making; they are too wet. Greenness is synonymous with wetness and green seeds must be allowed to dry or ripen.

Seeds change colour as they ripen. This is knowledge that women use to tell whether a bush food is ripe or not, and is often the subject of paintings. In her acrylic paintings on canvas, the Utopia artist Josie Petyarre for example, uses fields of dots in two or three colours to represent the different stages in seed development on canvas. Seeds are often Dreaming ancestors too, and as such changed shape and colour as they travelled across the country. Bush tomatoes, still a sought after food in the desert, are called 'yellow' when ripe, and 'green' in the stage before. Witchetty grubs are pink when young, white when mature and yellow when cooked. The colour that something will become, like the seeds classed as *tjinytjulu* by Pitjantjatjara speakers which come after yellow flowers, is a central concept. The dynamic of colour transformation in a seed is employed by artists in both regions to divide a string into rhythmic sections. In Arnhem Land the tiny plentiful seeds of the imported *Crotalaria* plant are used for their different colours during various stages of ripeness. Like many other artists, Anna Malibirr has strung together *Crotalaria* seeds in various stages of ripeness to give equal blocks of greenish-yellow, orange and dark-red in her pair of necklaces (4). Anna Malibirr was about 13 years old when she made these pieces in 2000. The green seeds before the yellow stage are too soft to be usable. Eileen Bloomfield (7) from Lytentye Apurte near Alice Springs in central Australia, has used one variety of gum tree operculum, the small frilled bud caps, but she has painted blocks of them in a repeating series of six different colours creating an effect with paint that is bolder and more dazzling, but similar to that of Anna Malibirr's necklaces.

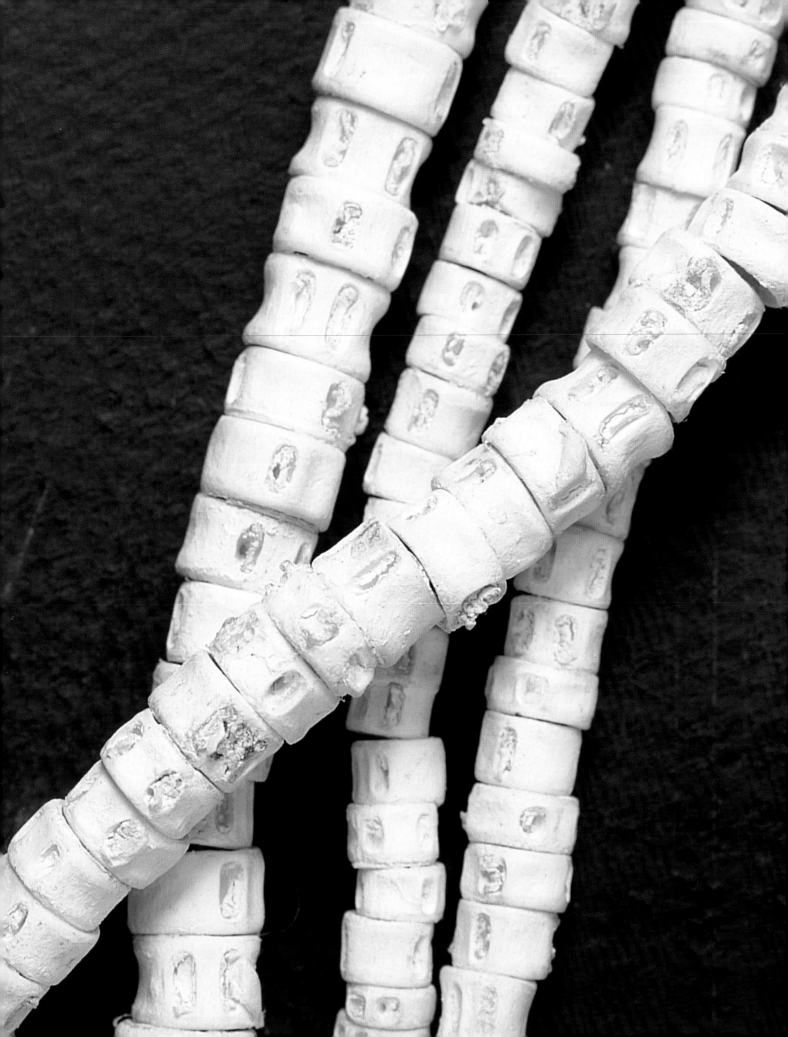

The colour of some seeds can be changed by boiling, something discussed more in the later section on making. There are two varieties of red seed used in Arnhem Land; one is the crab eye or *Abrus*. Usually a bright scarlet with a black dot, when threaded either side of a string with the black eye of the seeds facing inwards, red *Abrus* create a striking effect as in Walinyinawuy's long piece (62). The colour of *Abrus* can be manipulated by boiling them in water. The colour becomes darker the longer the seeds are boiled. The purple colour of the *Abrus* seed in Ngangiyawuy Guyula's necklace was made by boiling or cooking as artists term it. Ngangiyawuy Guyula has juxtaposed the two tones of the *Abrus* as solid runs of each colour (56) making a necklace with one half red, the other purple. The unusual salmon-coloured *Abrus* in WurrayWurray Gondarra's necklace was perhaps achieved by boiling. (53) It is possible to find totally black *Abrus* seeds in the Yirrkala region, and these are rare and thought highly of by women.[5]

In works made by Desert artists, the bat-winged coral seeds give an overall reddish-orange impression to pieces especially when seen from a distance. Like the red bead tree and *Crotalaria* seeds from the north, bat-winged coral seeds are classed by artists as having three or four different colours: red/orange, black and yellow. It is difficult to know why bat-winged coral tree seeds come in different colours—they do not relate to stages of ripeness. Some people say that different trees have different colour seeds, others say that one tree yields a mixture. Maudie Raggett's mat (23) uses these four colours very deliberately in the red and orange central cross shape on yellow, with black outer bands. Blocks or spacing of contrasting red and yellow seeds are common, Muwitja Brumby's made in 1998 (65) is similar to a necklace collected in Finke in 1931. Such red and yellow necklaces are still used as body wear, for ceremonial purposes in the Western Desert. Martha Palmer exploits the red and yellow contrast by triple stringing them interspersed with painted gum nuts (14) while Leonie Campbell has picked out spectacular single seeds, pale yellow, reds and dark purples on her strings of tiny black seeds (19).

TRANSFORMING COLOUR; PATTERN AND PAINT

Patterns of texture, colour and vibrancy are a part of Aboriginal artefacts and art works throughout the two regions. Pattern may enhance or disguise form. In both regions, any regularly occurring pattern or design is referred to by the same term, whether it is natural or cultural in origin. For example *walka*, a Pijantjatjara/ Yankunytjatjara term, seems similar to the Yolgnu of Arnhem Land '*miny'tji*', both meaning a deliberate mark or pattern making, including that on 'naturally' occurring things such as shells. Such things are classed by Aboriginal people as part of the meaningful cultural world, made by ancestors.[6] In the Desert where there are no

Philomena Wilson, detail of necklace showing shark vertebrae (2), 2000.

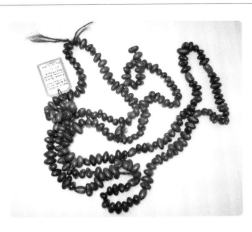

String of bat-winged coral seeds described as 'red and yellow' threaded on human hair, collected in 1931, Finke River, Central South Australia, 169cms long. Pitt Rivers Museum, University of Oxford, 1931.83.10.

naturally occurring patterned materials for art on a string, artists apply pattern to the surface of gum fruits with acrylic paint. Paint and ochre are applied to the surface of land snail shells in Arnhem Land, but the majority of pattern is already present on shells. The highly patterned 'necklace shell' varies immensely in pattern and colour. Tiny stripes spiral around the form of the shell. There are zigzag lines, bands of perfect diamond designs with contrasting solid colour, thin and wide stripes and networks of fine lines, all on a smooth glossy surface. Margaret Likanbirriwuy's (34) and Gulumbu Yunupingu's (35) necklaces of groups of shells, with markings so fine and deliberate that look like a printed pattern, are wonderful examples.

Others like the circular sundial shell, have a formal pattern and a highly textured surface. A lighter line spirals from the top of the shell downwards. Within this line there are divisions of raised dots and on top are dark brown elongated dots of colour. Barbara Rruwayi's pendant work (45) is a sundial with a tall spiralling shell hanging beneath it. Each section of the spiral shell tapers in and then expands outwards. In these sections parallel lines flow. In addition to the patterns inherent in the structure of the shells are patterns that are transformed over time, with the surf and sand causing a slow break down of pattern. The necklace shells chosen by Mabel Anaka-anaburra (10) have had their once bold marking worn away by the sea and are now almost white.

In contemporary artists' work from central Australia the predominance of painted gum nuts, reflects the widespread availability of acrylic paint and the large number of artists in the region now producing paintings on canvas with acrylics. In the Western Desert, transforming gum fruits with paint began in the late 1980s.[7] Many artists use black as a base coat, whatever colour is applied on top. This practice accords with 'priming' canvases with black paint, one carried out by many central Australian artists and used as a black 'skin' on the canvas. Bright colours overpainted on such black backgrounds glow like red ochre rubbed into black skin on a body. Individual artists have their own signature way of making, and it is often possible to guess where the artist lives on the basis of the style of painting as well as the shape of the gum fruits used. For example, artists working in the belt across the north of South Australia, Pitjantjatjara and Yankuntyjatjara and into Western Australia, Ngaatjatjarra are well represented in *Art on a String*. One of the types of *walka*, or design that artists use, is painted lines radiating out from the holes at each end of a bead. These break in the middle of the fruit at its fattest part, where a different design, usually a ring, is painted. Muwitja Minyirtirnyi's pair of bracelets (33) and Judy Davis' pink necklace and bracelet (50) are painted in this way, each bead as a repeated pattern of the others, but on three different sorts of seeds. Betty Munti's blue and red necklace (74) uses the same design but with bolder strokes of colour. Panjiti McKenzie's curtain uses a loose version of this design. Artists in this area use the same design on large umbrella-shaped gum bud caps as Esther McKenzie (68), with strokes of colour radiating from the top.

Gulumbu Yunupingu, detail of patterns in necklace shells (35), 2001, necklace shells and beeswax threaded on hand-spun string.

Artist unknown, representation of a coolamon (wooden carrying bowl) filled with bat-winged coral seeds, and a seated woman at each corner. Made from *nyitu* (small brown seeds), black, red, orange and yellow bat-winged coral tree seeds glued onto MDF board.
Photo: Andrew Stevens.

Sometimes artists use this radiating pattern in a different colour combination for each end of a bead. This can create a startling directional effect if the beads are all strung with the pattern facing the same way. Daisy Nyukana Baker (85) and Alison M Carroll (41), both senior Ernabella artists use this technique with pattern, as does Judy Davis (49) from nearby Watinuma.[8] Alison M Carroll's gum fruits painted black with a green and white radiating pattern at one end and a red and yellow one at the other, create a directional necklace that relates to country; the red/yellow relate to fire and the green/white to green growth and rain. Judy Davis has used a similar series of colours to give a subtle directional effect. She is known for her very finely painted *walka*, tiny dots and strokes of colour, and her desire to reproduce these throughout a whole necklace. Daisy (Nyukana) Baker's curtain contains many strings with spectacular directional lengths in bright colours. As a batik artist Nyukana Baker is known for her pastel colours—pale pinks and browns for example.

A design painted on the sides of a gum fruit bead is also used by artists here. One form is a radiating shape from a central disc. Daisy Baker's curtain contains strings of black painted beads with a yellow disc design and blue 'arms'. This design is used in batik by artists in Ernabella and Amata. Honey ants, or more unusually, witchetty grubs, are also used as pattern making on the fat part of the gum fruit. Diane Brown's witchetty grubs are pink (and therefore young), surrounded by witchetty bushes and white slashes (51). All-over two or three coloured dotting as pattern on beads is something practised more by artists living in Alice Springs and further north where there is a more entrenched style of such painting on canvas. Agnes Petrick's black-painted round gum fruits overdotted with red, violet and green and spaced between yellow bean tree seeds (26), is an accomplished example of this genre, as is Joanne Ken's gum beads , black dotted over with white, yellow and metallic gold (52). Polka dots, wider spaced dots ringed in other colours and reminiscent of dress prints, are another style as seen in Kangitja Mervin's painted gum fruits interspersed with radiating patterned ones (61 and 31). She has used a straw or hollow plant stem to print circles on her beads. Bright pinks, even fluorescent, and mauves are a sought after colour combination in clothes. Daisy Baker's curtain contains some strings of beads painted with this combination. Lucy Ashley's large land snail shells (42) painted variously in black, greens, yellows and reds, features one bright pink painted shell which makes the whole work sing. T. Kunmanara's spectacular highly patterned and multi-coloured string of gum fruits are painted in two alternating designs (16). The striped violet design (made up of tiny marks) is highlighted by one bead overpainted with pink paint giving a luminous effect. Kunmanara was credited, with her late husband, as being the artist who brought 'dot painting' to Ernabella in the late 1980s.

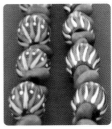

Alison M Carroll, detail of necklace (41), 2001, showing directional pattern. Each bead is painted with the same design but is strung so that it appears quite different depending on the direction of view. Photo: Andrew Stevens

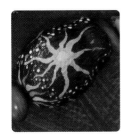

Daisy Baker, detail of Fly Curtain (85), 2001, showing bead with blue design. Photo: Andrew Stevens

The gum fruits painted in ochres by Lena Kuriniya are unusual materials for an artist in Arnhem Land to be using (55). The necklace is the spatial inverse of the bracelet, the necklace—black with white and brown overpainting, the bracelet—white with black and brown stripes and dots. The same pattern appears on snail shells of overdotted stripes (24). Eva Napananka Kelly's necklace of different seeds, freely and vigorously painted in bright colours is in a style of many Warlpiri artists. The hanging *Hakea sp.* seeds, found in the Tennant Creek area and north, are used here like the long conical shells in Lucy Ashley's necklace (66) or Mabel Anka-anaburra's red and white one (12).

Cissy Riley, a senior women, has painted four bloodwood fruits, spaced between deeply indented bud caps, in a tactile way like body painting, using red, yellow, white and black or dark blue. Although red and white are not used much in the Western Desert, in *Art on a String*, red, yellow and black are a common set of colours. Together they are fire colours—all the colours fire can make. A fire is the focus of social life. Fire is used to maintain the fertility of country in both regions by burning off older growth to stimulate new green shoots that will bring in game. Nungalka Wirtima's necklace uses these colours and a design perhaps more like body painting than that of younger women. The carved wombats and parrots in Niningka Lewis's bracelet are painted using the patterns normally applied as poker-work—branding patterns into gum fruits using hot wire—to carvings. She has used red, white, yellow, and orange on black underpainting. Such carved bracelets are more commonly made with branded pattern on the carvings.

A motif that artists use throughout the central area on seed beads, as well as in painting on paper and canvas, is a dot ringed with smaller ones orbiting it. In this exhibition, Martha Palmer's mauve seeds (15) are patterned in this way and Eileen Watson's long work (22) has a few black gum fruits painted with it. Joy McArthur's necklace is one of the most formal in *Art on a String* with its beads in symmetrically patterned pairs, culminating with a metallic gold bead (13).

Poker-work is often used when artists have no access to paint, but it is also a style of pattern in its own right. Hermannsburg artists produce poker-worked necklaces more than any other community. Stripes going up and down or spiralling the gum fruit predominate, as in Agnes Petrick's necklace, but all-round stripes and dots are also used.

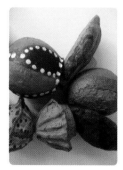

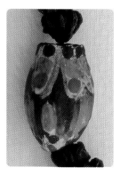

Agnes Petrick, detail of
necklaces (26 and 27), 2001.

Eva Napanangka Kelly (22),
1999, detail of necklace
showing painting on beads.

Cissy Riley, detail of necklace
(81), 1998, showing painted
bead. Photo: Andrew Stevens

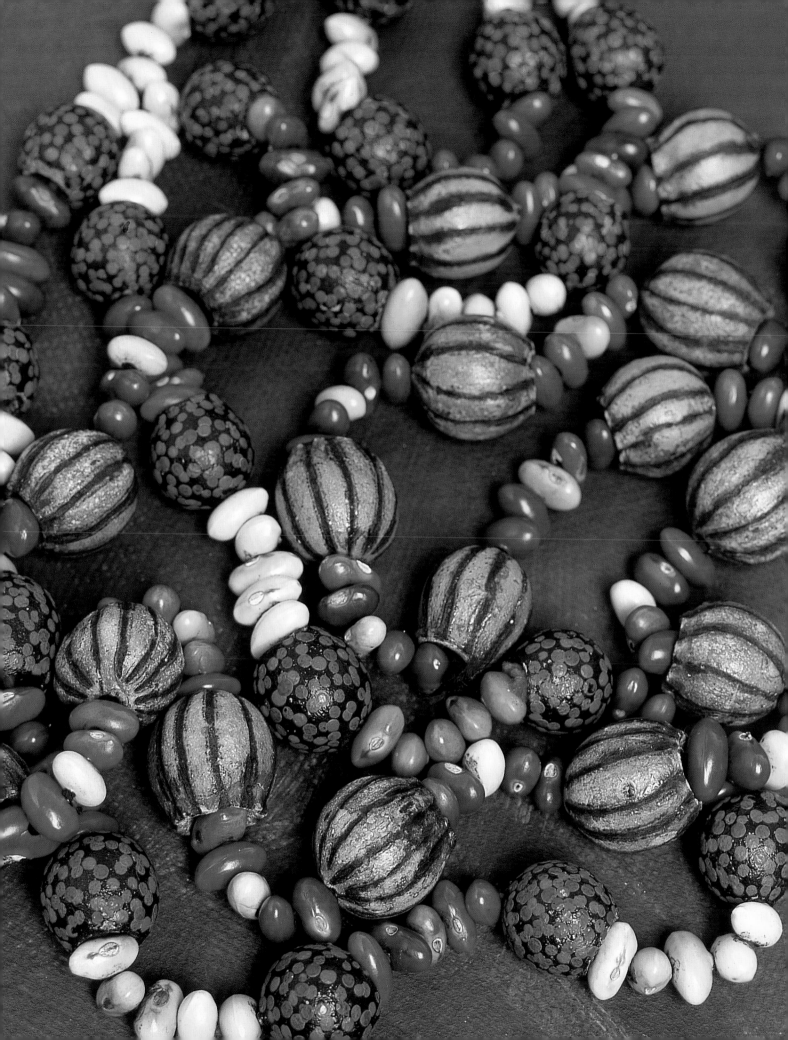

RHYTHM

By changing pattern, colour or material, artists create striking formal rhythms. The repetition of words in everyday speech and in songs finds its counterpoint in the repetitive rhythms of many of the works in *Art on a String*. Perhaps having fewer materials to choose from, Desert artists have been inventive with ways of combining these seeds. A regular number of red bean tree seeds spaced between gum fruits, is one of the most conventionally made rhythms by Desert artists. A similar rhythm is created by Mamuniny from Elcho Island, in her spectacular lengths of shark bone with intervals of concentrically coloured bunches of feathers (46 and 47). In Arnhem Land, the decorated strings are similar in their detail and elegance to the cross-hatching of bark painting, although actual cross-hatching never seems to be applied to them. The red and white rhythmic dazzle of Elsie Marmanga's necklaces for example, or the exquisite regular repetitive groupings of yellow shells, pink shells and darker material—crab legs or seeds—in Celia Marbin's work (36 and 44).

By piercing identical seeds in different planes the threaded configuration can be made into staccato rhythms, as in Djupuduwuy's necklace of small black seeds (75). The way in which the seeds are threaded can give many textures and syncopation to a work. Elsie Marmanga from Maningrida creates a whole panoply of mathematical rhythms in the contrast of red bead tree seeds and white tusk shells (9 and 11). She uses double strung rows of five red seeds separated by one white tusk shell as a spacer; 5,1,5,1,5. She went on to create a whole series of these; four red bead tree seeds to one tusk shell; 4,1,4,1,4; and two red bead tree seeds to one tusk shell; 2,1,2,1,2. A more complicated pattern is set-up in alternating groups of the same seed; three red seeds, one white tusk shell and two red seeds; 3,1,2,1,3; and by adding a third material, tiny yellow necklace shells to each side of a red bead. Nellie Nambayana, with her unusual combination of lines of six double-strung bat-winged coral seeds spaced between sundial shells, achieves a similar rhythm of colour changes, but with a totally different result (69).

In the Desert, Cora Campbell has taken unusual dark brown red bean tree seeds and similarly dark brown *nyitu* seeds to create rhythms, relying not on contrast in colour but on shape and shine, of three red bean tree seeds and three *nyitu* in one necklace and a three to two pattern of the same beads in another. These necklaces were picked out by Dora Haggie and Paninyi, two Pitjantjatjara women, in Hermannsburg, as being especially fine or because of their colour and exactly counted seeds. This mathematical aspect of pattern is a part of the rhythmic cadences of ceremonial music and song in both regions, tapped out with music sticks or boomerangs or whatever is to hand. This rhythm is used to represent the protagonist of the song, and the way she moved along through country.[9]

Typical Arnhem Land burning
off country, Cannon Hill,
Arnhem Land, 1998.

The continual precise repetition employed in song, accords with the convention of repeating speech. In north-eastern Arnhem Land people have made long ceremonial feathered ropes for many years. Sometimes they are composed of single strands of feathered string wound together in certain places. In others the string is composed of densely-packed coloured feathers wrapped onto string. Sections of wax, or change of feather, colour marks a rhythm change which often equates with a different place in the country. The long seed necklaces from Arnhem Land with their changes in rhythm created by seeds or shells is evocative of those relationships.

The two *punpunpaku*/fly curtains both made by Ernabella artists show two different approaches to the design of such a large piece of work. Daisy (Nyukana) Baker (85) made each string separately, and while their juxtaposition is considered, the main emphasis of the work is in its vertical rhythms of painted gum fruits spaced between red bean tree seeds. Panjiti McKenzie (86) has made the pattern of colours in the painted gum fruits across the curtain especially emphasised by the white, pink and metallic blue painted gum fruits.

Something of the richness, complexity and individual artists' creativity of *Art on a String* may now be apparent. Next, the meaning inherent for artists, in materials and country, is explored. Much of this too, is about colour.

endnotes

1. E Michaels, 1994, *Bad Aboriginal Art: Tradition, Media and Technological Horizons*, Minneapolis, University of Minnesota Press.

2. D Thomson 1975, 'The Concept of *Marr* in Arnhem Land', *Mankind 10*, pp.1-10.

3. D Young, 1998, 'Pu<u>n</u>u; Metaphors and Markets: Wood carving in the Ernabella region' in *Warka Irititja Munu Kuwarikutu/ Work from the past and the present*, Louise Partos (Ed), Ernabella Arts Inc.

4. WB Spencer, and FJ Gillen, 1899, *Native Tribes of Central Australia*, MacMillan and Co London, New York, p.27.

5. Glen Wightman personal communication to Louise Hamby.

6. D Young, 'Colour and Social Remembering and an Anthropology of the Senses in North-west South Australia', PhD Thesis, University College London, 2001; H Morphy, 1989, 'From Dull to Brilliant: The Aesthetics of Spiritual Power Among the Yolgnu' in *Anthropology, Art and Aesthetics*, J Coote and A Sheldon (Eds); Oxford, Clarendon Press.

7. About 1986 at Santa Teresa (Ltyente Apurte), and a little later at Aileron further north; see also interviews on p.60 and p.65.

8. Both Nyukana Baker and Alison M Carroll are consummate batik artists, printmakers and painters.

9. For example, in the north west of South Australia, rhythms created by women to structure songs are the slow 'gapped beat' and faster single notes or pairs of notes, p.72-3 in CJ Ellis, AM Ellis, M Tur and A McCardell, 1978, 'Classification of Sounds in Pitjantjatjara Speaking Areas' in *Australian Aboriginal Concepts*, L Hiatt (Ed), Australian Institute of Aboriginal Studies, Canberra.

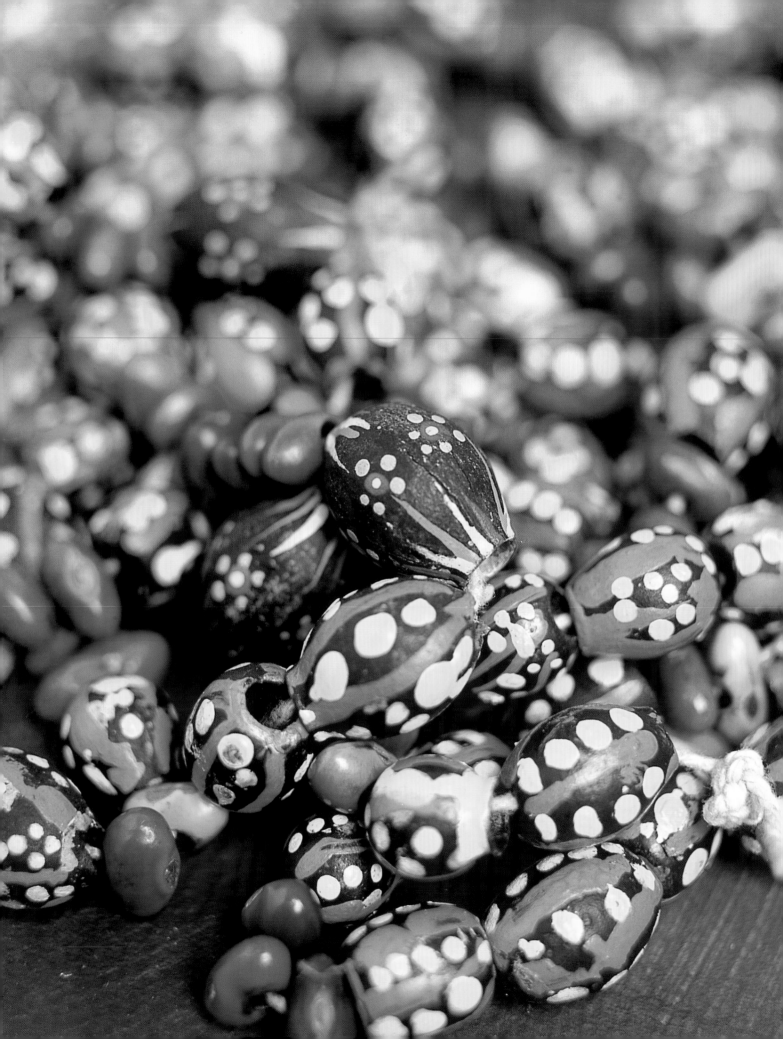

MATERIALS AND COUNTRY

THE THREADED OBJECTS FROM THE CENTRAL DESERT AND ARNHEM LAND COMPOSED BY THE ARTISTS REPRESENTED in *Art on a String* are significant not only for their aesthetic qualities but for their relationships to people, their country and the historical use of similar objects. Artists have various criteria for determining the final outcome of their work such as the appropriate material, the desired colours inherent or applied to materials, the combination of materials and composition with certain rhythms. Although the priorities are not the same for each individual, choice of materials emerges as a high-ranking factor.

Because the sea and other water sources provide many possibilities there is a greater diversity of materials in Arnhem Land. Most of the materials selected are natural and have their origin in the country of the maker. In central Australia bat-winged coral seeds form the staple component of necklace making. These seeds are given as presents among families or even purchased in Alice Springs. The pursuit of the right material gives rise to travel and trade, strengthening relationships with Aboriginal people living in other parts of the country. Resources are found across vast distances and diverse terrains, some favouring particular environmental conditions. Women use natural products including animals, birds, sea creatures, plant parts and hand-spun string for the core of their work. Other products manufactured outside of communities add to the array of choices available to artists. These include manufactured beads, plastics, wool and cotton yarn, fishing line and acrylic paints.

Artists are dependent on the land and seasonal conditions for access to these natural materials and must have knowledge of the country to be able to use them. Many seeds are only available at certain times of the year. Tiny *Crotalarias* are found in Arnhem Land during the winter and in the Desert many seeds only appear when there has been sufficient water several months beforehand. In order to create the threaded works artists draw on a large knowledge base that includes seasonal, geographic, botanical and general information about the country.

For Aboriginal people throughout Australia, land or country is very important because of its connections with ancestral beings. Ancestors moved through the landscape creating all parts of it by their actions and the people who were to live in it. People maintain connections to the land and have a reciprocal relationship with it. Banduk Marika, artist from Yirrkala, expresses this relationship in an interview with Stephanie Britton:

Eileen Watson, detail of
necklace (22), 2001.

"This need, to be fed from the sea and from the land, is there because Aboriginal people regard the body as land and the land as body, both creators and givers, and if people don't care they both will die.[1]"

That strings, and in particular elaborated strings threaded with seeds, are conceived by the artists as a part of the land, is shown in the paintings of two Arrernte artists, Faye Oliver and Julie Hayes, both based in Alice Springs. Faye Oliver shows necklaces as meandering creek beds passing through country filled with different gum trees bearing different shaped gum fruits used for necklaces. Julie Hayes paints the creek beds as curving lines of red and yellow bean tree seeds. There is a sense here of strings forming an element of the land and of the land as a body. Wearing strings or things threaded onto string connect the wearer to the land.

Gulumbu Yunupingu is a strong advocate of producing art with resources that come from the land. She and her sisters learned to paint from their Gumatj father Mungurrawuy Yunupingu using natural ochres. She lives in the Yirrkala area and her art practice includes painting, sculpting, twining and making necklaces. During discussions with her about making art she emphasised the value of materials from the environment. "What grows in the bush and the sea is *manymak* [good]." Not only does she feel these are superior materials for her she also sees the land as the primary source of survival. She says:

"*Rrupiya* [money] comes from the land and the sea. Yolngu live on the land. Money does not come to you but Yolngu look for money—work for money and it comes from the land. You can make it yours."

Gulumbu's recent necklaces in *Art on a String* are unique in their pendant form that features not only the threaded objects consisting of cut shapes but also the threading material itself; two-colour hand-spun string. All of the materials in her shark pendant come from the land and the sea; string made from Kurrajong fibre *Brachychiton megaphyllus*, shells, the shark cut from the shell of a sea tortoise and the Mecuna seed (83).

Materials that come from Aboriginal people's country, whether it is the air, land or sea, all hold meaning for specific groups. In some cases individuals or groups are the custodians of a particular plant or animal. This could be due to ancestral links or the plant or animal item may reside on their land. Ownership and rights to materials and designs are important considerations for Aboriginal artists. This issue is one that arises through the works in *Art on a String*.

The following sections examine specific groups of materials employed by artists in *Art on a String*. Within these stories we examine issues of relationships to country, ownership and the incorporation of other materials. The first story looks at meaningful materials that have flowed into Arnhem Land, like gifts from the sea.

Julie Hayes, *Women Collecting Inernte seeds* (bat-winged coral seeds), 2001, acrylic paint on canvas.

Some women are collecting *inernte* seeds in their coolamons. The other women are sitting around the fire burning holes in the seeds with a hot wire. You get a piece of wood and make a little hole in it to hold the seed then burn it with a hot wire out of the fire. The *inernte* tree likes to grow on the sandy creek banks. The stripey lines are the creek beds in that country.
Julie Hayes speaking about her painting *Women Collecting Inernte seeds*.

During certain times of the year, when the south-east trade winds blow, many things wash ashore following the currents along the coast of north-east Arnhem Land. In the past food items like coconuts were thought to be gifts from the island of the dead. Gifts, including unusual seeds, still wash onto the beaches and are collected by women for use in necklace making. The seeds known as 'marine drift seeds' by botanists are important areas of study. Perhaps the most unusual is a large lustrous brown seed commonly known as the matchbox seed. The tree, *Entada phaseoloides*, does not grow in Arnhem Land but can be found in Queensland and the Torres Strait Islands. The seeds are the largest ones used in *Art on a String* at approximately 50mm long, 45mm wide and 22mm thick. In north-east Arnhem Land these seeds are known as *gurunggurr*. They are Yirritja seeds and are sung about in songs. There is a history of these seeds being used by early Aboriginal and non-Aboriginal Australians. They were made into scent bottles and other containers heavily decorated with silver by non-Aboriginal Australians while Aboriginal people were making necklaces.[2] One long necklace, held at the Australian Museum and collected by Harry Stockdale in the 1890s from western Arnhem Land, has been a catalyst for discussion and activity.

At Elcho Island Peter Datjin Burarrwanga, Priscilla Ganangarrpul Dhamarandji, Yvonne Dhawuratji Ganambarr, and Caroline Bunhala Burarrwanga, Aboriginal staff at the Elcho Island Art and Craft Centre, told Louise Hamby they had found these large seeds washed up on the beaches on Elcho Island. They explained that there were restrictions involving the use of the seeds. They were not to be picked up by children and it was also important that the *gurunggurr* seeds should not be burnt. They said it "produces a red cloud of smoke which is very bad and will make you sick".

After spending a day on the beach at Yirrkala, Nonggirrnga Marawili placed one of these seeds in Louise Hamby's hand and said *rangilil* [from the beach]. There was discussion among some of the women about the seeds which resulted in an interview with Nonggirrnga Marawili and the necklace made by Merrkiyawuy Ganambarr (pictured).

Faye Oliver, *Bush Necklace*,
2000, acrylic paint on canvas.

The red, yellow, white, grey and pink dots are the different bloodwood trees that have gum nuts used to make necklaces. It is good to hang necklaces up on the wall.
Faye Oliver speaking about her painting *Bush Necklace*.

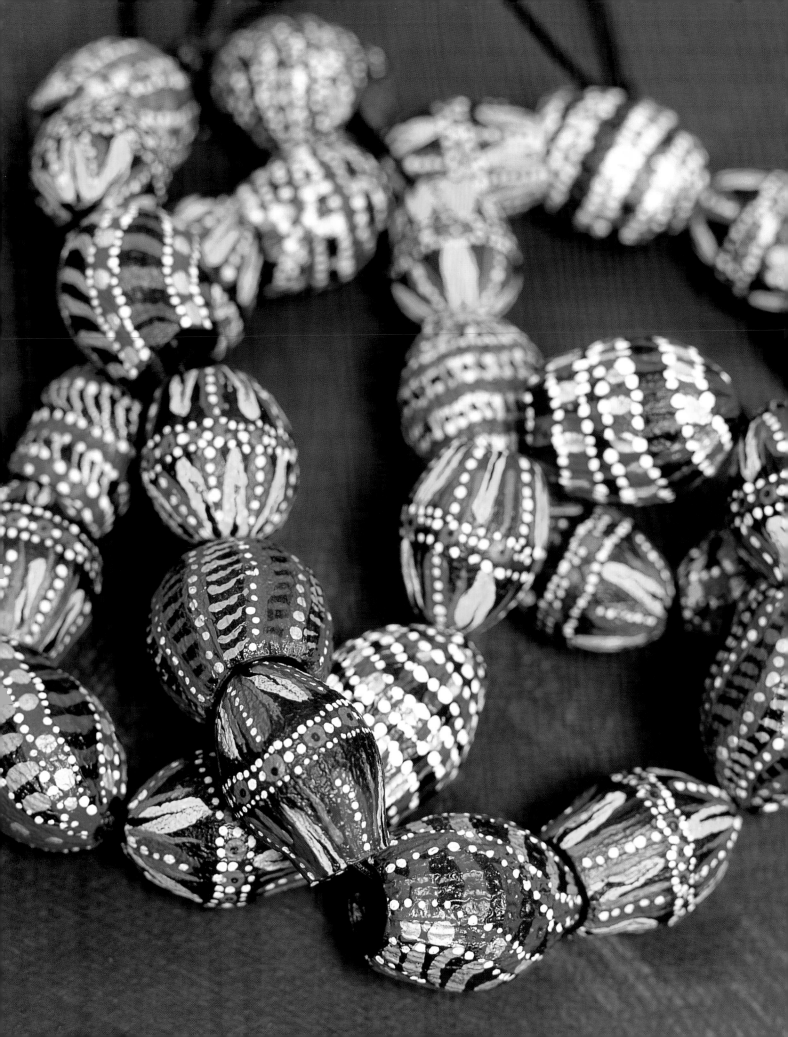

Matchbox Seeds

Date: April 29, 2001, People: Nonggrinnga Marawili and Merrkiyawuy Ganambarr and Louise Hamby, Place: Yirrkala.

LH Can she tell me about these seeds?

NM It is a seed called *gurunggurr*. And they come in different sizes, *ga* [and] shapes, *ga* colours but they are all one and they come from somewhere to the east. They all float on the water and follow the currents until they get here to our beaches. 'Cause when we went to Thursday Island, long time ago. We saw this tree and it had these seeds in it, really big pods, long ones. It had these seeds like they would have been *mak* [maybe] four or three or *nhawi* [whatchamacallit] and then we realised it doesn't grow here. It grows up in the TI [Torres Strait] somewhere in Queensland.

LH How would they make the hole?

NM Made holes by a hot wire that goes in the middle or at the top, and thread them through with strings. It is to put around neck or as gifts to other people. Long time when they used it. It was a gift. Their string was twisted made by rubbing on the thighs. Only women made it. Only *miyalk* [women].

LH Did they give them to other women?

NM Other *miyalk* or men.

Merrkiyawuy Ganambarr produced a necklace for the exhibition using various drift seeds that follow the currents. Although this necklace was not made as a gift and differs in appearance from those made in the past she was guided by advice from the older women about using the *gurunggurr*. The centre portion of the necklace is composed of a symmetrical arrangement of large seeds. The four *gurunggurr* are separated by a large flat shiny black seed and two slightly flat brown seeds. All of these are known as *gurunggurr*. The black seed and the two brown ones are *Mucuna gigantea* which are a native climbing legume found in jungle type environments but these seeds still wash up on the beach. Framing these heavy dark seeds are two large grey irregular seeds *Caesalpinia bonduc*. These almost pearlescent seeds form a bridge between the large seeds and the small necklace shells. Boiled crab eye seeds form the major portion of the necklace (43).

T. Kunmanara, detail of necklace (16), 2001.

Merrkiyawuy Ganambarr and Nonggirrnga Marawili discussing the making of necklaces with matchbox seeds, Yirrkala, 2001.

A matchbox seed (*Entada phaseoloides*), one of many marine drift seeds that wash up on the shoreline in Arnhem Land, Yirrkala, 2001.

The two most dominant seeds used by artists living in central Australia are gum fruits and the distinctive bat-winged coral seed, from the bean tree, which only occurs naturally north of Alice Springs.[3] Possessing bat-winged coral seeds is often a catalyst for making string and bead pieces and the bat-winged coral seeds are given as gifts over a large area of the Desert. The area around Papunya is often cited by artists in the southern areas as the place where bat-winged coral seeds come from. Harts Range is well known as a bean tree place. In this area watercourses are filled with bat-winged coral rather than the usual eucalyptus.

Today there are ownership rights over certain bat-winged coral trees or stands of trees. Agnes Petrick for example, has planted a bat-winged coral tree in her own garden and another across the road from her house. She distinguishes 'brown' bean trees from 'white ones' by a variation in bark colours. On the Pitjantjatjara Lands to the south, where the bat-winged coral tree is not native and may be frosted during the colder winters, some bat-winged coral trees have been planted in gardens and on homelands. The rights to the seeds belong to the owner of the country or patch of ground where they grow. Recently bat-winged coral seeds have been sold 'raw' to shops in Alice Springs and purchased by art centres and individuals by the kilo.

Although this tree also grows in Arnhem Land artists there rarely use its seeds. An exception is seen in a necklace by Nellie Nambayana from Maningrida (69). The bat-winged coral seeds are double strung and come together through two sundial shells back to back. The shells and seeds form a strong visual link between the two dominant countries.

Arnhem Land artists do not generally use gum fruits. There are two unusual examples in *Art on a String*. In the exhibition Desert branding is seen in Daisy Kanari's bracelet (3) and Agnes Petrick's necklace (27). The necklace by Mamuniny #2 from Elcho Island in Louise Hamby's collection is a surprise because of its use of bat-winged coral tree seeds and also of branded gum fruits. This necklace was made at a time when visitors from the Desert were at Galiwin'ku for a Christian religious festival. It is most likely that some of these visitors brought their work with them, thereby increasing its influence in the area. Although the branding technique is highly characteristic of the Desert the technique of using hot wires for burning is known in Arnhem Land. In the following interview Mamuniny establishes the practice of using hot wire as an old one used by senior women in the past.

White bat-winged coral tree, north-west of Alice Springs.

Brown bat-winged coral tree, north-west of Alice Springs.

The four colours of bat-winged coral seed, classed by artists as 'black, red, yellow and orange', Alice Springs, 2001.

Hot Wire

Date: May 4, 2001, People: Rose Mamuniny #2, Steve Westley and Louise Hamby, Place: Galiwin'ku.

M Djäkminydhu *dhiyal* first.
It was Djäkminy who did this first.

SW That's Datjin's mother, the eldest sister.

LH Did she use that hot wire?

M Yeah put-in *gurthalil*
Yes, she put it into the fire.

LH And the name for the [gum fruits] was?

M *Gungurru dhuwalnydja, gungurru, nhä wändwa wändwa yutjuwala nhanngu*
That one is woollybutt, and there's also bloodwood, the little one is similar to it.

SW When Djäkminy did that *djäma* [work] did she use a *nyumukuniny djimugu*?

M *Yo nyumukuniny djimugu*
Yes a thin spear-wire

LH So *miyalk* [women] have been making these here for a long time with that hot wire?

M *Yo balanyar bili* my mother, Djäkminy's mother
Yes, my mother and Djäkminy's mother were always doing it like this.

Seeds of a different kind feature in the work of two women, Mary Muyungu (now deceased) from Elcho Island and Leonie Campbell from Alice Springs. Although the seeds they have used in their work are not native to their particular country, they were sought after by the women. One of the reasons may be that these seeds are quite different to the types of materials that other women use, thus making their own work quite distinctive. It is highly unlikely these two women ever met or saw each other's work, yet there is a strong connection in both composition and materials. Mary Muyungu used the brown seeds of the coffee tree bush *Leucaena leucocephala*. This tree was introduced as cattle food and cultivated in Darwin in 1958. It needs a fair amount of water and warmth and is not likely to flourish in the Desert. From 1967 there is record of three or four of these trees found in Alice Springs but no information about how they came to be there.[4] Although the seeds that Leonie Campbell uses in her necklaces have not been positively identified they are very similar in shape, size and colour to the coffee bush seeds of Mary Muyungu. The tree Leonie Campbell uses was planted at Morris Soak by the local

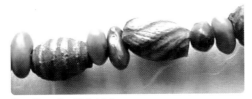

Rose Mamuniny #2, A detail
of a necklace with designs
produced on Elcho Island by
burning with a hot wire
djimugu, 2000, gum fruits
and bat-winged coral seeds
threaded on fishing line.

Council. Here there are also issues of ownership over the use of the seeds. The art adviser at Elcho Island, Brenda Westley, said that Mary Muyungu was very protective of the tree she used and would not allow anyone else to use 'her' seeds.

In examining the work of the two women, it appears both compose their necklaces with similar seeds, sometimes broken by a single element or a small group—in Mary Muyungu's case shells. Leonie Campbell sometimes uses different coloured bat-winged coral seeds, gum caps or most recently painted gum fruits.

Other works thread together country that is closer in proximity, as seen in the work of Djarryjarrminypuy Birritjiama who lives in Gapuwiyak. In her long necklaces, she breaks passages of small densely-packed *Crotalaria* seeds regularly with small-patterned necklace shells. She includes shells in her necklaces that she collects on trips to Galiwin'ku where she used to live. On Elcho Island, artists often make entire necklaces with shells of different varieties. Djarryjarrminypuy's combination of seeds and shells in this manner is a connection of the two countries where she lives, coastal and inland (58).[5]

THREADING GRASS STEMS, PAST AND PRESENT

Necklaces made from grass stems known as _nanarr_ have not been a feature in the styles of necklaces available commercially from Arnhem Land. Perhaps some of the reason for this is that they have been more a part of everyday and ceremonial use within Arnhem Land communities. In the early 1990s Mick Kubarkku and his family from Maningrida were making plain and ochred grass stem necklaces and breast harnesses. This was in response to seeing similar items in rock art in his country. In 2000 Djupuduwuy Guyula from Gapuwiyak made a grass stem necklace which sparked interest from Louise Hamby and from other women in the community. In Gapuwiyak the grass stems used are *Leptoehloa fasca* while other grasses are used elsewhere. Djupuduwuy Guyula's necklaces in *Art on a String* are constructed from plain grass stems threaded on hand-spun string and are elegant in their simplicity (80 and 84).

There is a long tradition of making and using grass stem necklaces in Arnhem Land which is evidenced by their numbers in museum collections. The older necklaces have in common multiple strands of grass stems which are tied in a choker fashion around the wearer's neck. The threading material varies and includes vegetable fibre string, possum fur and human hair string. Some of the necklaces are quite elaborate with the addition of pendants, for example the necklace from the Ritharrngu people in the Donald Thomson Collection (pictured).

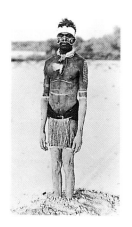

An enactment of a ceremony by Wulagi people. The articles worn on the body are significant. The necklace the man is wearing is very much like the one pictured. 1930s. Photograph by D. F. Thomson. Courtesy of Mrs D.M. Thomson and Museum Victoria.

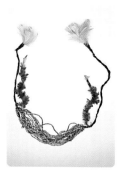

Unknown Artist, This elaborate ceremonial _nanarr_ belonging to Ritharrngu people was collected by Donald Thomson. The grass stem works in the exhibition are constructed in the same manner but with hand-spun Kurrajong string. 1930s, grass stems threaded on spun human hair, attached pendants of red-collared lorikeet feathers. The Donald Thomson Collection, On loan to Museum Victoria from The University of Melbourne.

Djupuduwuy Guyula, Lucy Ashley and Anna Malibirr, detail of painted and unpainted grass stem necklaces, 2000.

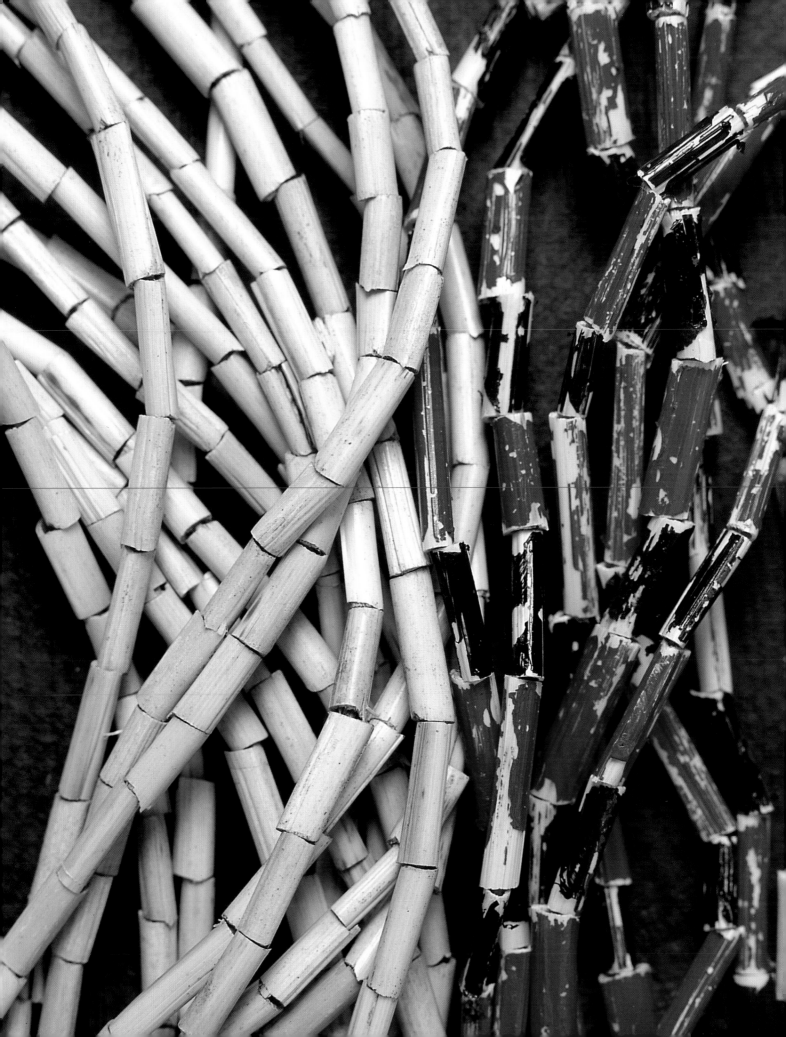

This work has two short red-collared lorikeet *Trichoglossus rubritorquis* feather pendants ending with part of a crest from a sulphur-crested cockatoo *Cacatua galerita*. It is threaded on hair string with tying strings also of human hair and white feathers on the ends. This elaborate necklace would have been worn in ceremony. In the photograph by Donald Thomson, the man in the ceremony is wearing this necklace, or if not, one very similar.

According to Peter Datjn and his family, grass stem necklaces that are threaded on human hair play an important role in mortuary ceremony. When a man dies his widow wears a grass stem necklace made with hair from the head of her dead husband. A relative of the widow makes the necklace for her to wear. Other members of the deceased family (male and female) would also wear grass stem necklaces but these would be threaded on hand-spun plant fibre string. The women would have special paintings on their chest and wear breast harnesses. There are other ceremonial events in which these necklaces would also be worn.

Grass stem necklaces were also made for everyday wear. Lucy Ashley remembers her mother telling stories about people using grass stem works as body adornment. Breast harnesses made from grass stems were worn by young girls until they were married and were believed to make their breasts strong. The string was finely spun for use with grass stems and sometimes the women would ochre the stems in red, yellow and black. Lucy Ashley and her daughter Anna Malibirr have a necklace made with the same material but they have applied a very contemporary method for colouring the stems using red and black acrylic paint, which harks back to her description of earlier pieces that were ochred (39).

SEEDS AND COUNTRY

As we have seen seeds are an integral part of making necklaces in both the Desert and Arnhem Land. Some seeds are native to the country where they are found while others have been introduced to that country either by deliberate planting or accidentally by those outside of the communities. These plants are often still thought of as belonging to a particular person or group of people because they are on their land.

Gum fruits and bud caps from the scores of eucalyptus that are native to or introduced across central Australia, are variable in shape and size. Artists exploit these variations. In Alice Springs there is an especially wide choice available. While being shown photographs of bud cap necklaces in Alice Springs, a Pitjantjatjara woman, explained: "*Kala, kutjupa. Kutjupa apara kutjupa walypalaku.*" (Lots and lots of different colours from other kinds of (River red) gum. Whitefella trees).

Collecting gum fruits *tatu* from large bloodwoods, *itara* or *muur-muurpa*, on the Anangu Pitjantjatjara Lands. The tyre tracks of pale grass show habitual visiting of the trees, north of Ernabella, 2001.

Panjiti McKenzie collecting gum fruits, north of Ernabella, 2001.

The bloodwood is a variable genus. The (*Eucalyptus*) *Corymbia chippendalei*, sandhill bloodwood which grows in the Utopia area and further north, has fatter fruits. Agnes Petrick uses these in her necklaces and the fruits are native to Hart Range where she lives. But artists often use materials they have been given or those that they have collected while travelling. Both T. Kumanara's piece (16) and Daisy (Nyukana) Baker's fly curtain (85) contain big gum fruits collected from gum trees (perhaps *Corymbia ficifolia* or *Calophylla*) growing in Adelaide while they were staying there in early 2001. Pitjantjatjara and Yankunytjatjara artists call all such gum fruits *tatu* but distinguish them by shape, *tjuku tjuku*, small, *pulka*, large or fat. The necklaces of Yangkuyi Yakiti (73) from Ernabella, Betty Munti (74) from Ernabella and Amata a little way west, and Kangitja Mervin (61) from Watarru to the south, are all made by alternating small and large gum fruits. The small ones are said to come from smaller trees, while the others are from the large sprawling, multi trunked bloodwoods that grow in this area. These are often sacred trees.

From central Australia the brownish seeds, too small to paint, and used for their natural colour as a change from bat-winged coral seeds, are called *nyitu* in Pitjantjatjara. These are from a small shrub, *Stylobasium spathulatum*, said by artists to grow 'anywhere'. Hermannsburg artists often use them with bat-winged coral seeds. Bessie Liddle has used them with bat-winged coral tree seeds and gum nuts (28) as has Niningka Lewis in her bracelet (82).

Quandong fruits have red, shiny skins and used to be highly sought after as food. There are a few of these trees left in the north of South Australia where the population was decimated for wood carving in the 1970s. The small trees grow in sand hill or open country and are distinguished as being a different green from neighbouring trees. They are now more sought after for the *tatu*, the spherical, textured seeds, for necklace making. As with other seeds used as beads, it is the old dry seeds left on the ground that are best for making necklaces. Like gum fruits, artists usually paint these seeds. Judy Davis's bracelet and Joy McArthur's work both feature painted quandong seeds. The shiny gold paint on Joy McArthur's quandong beads (13) shows off the texture. Because of their bumpy surface, painted designs made on them are less precise. Judy Davis has reproduced the same repeat pattern on her bracelet as on her necklace (50) with different results. Betty West's necklace (21) includes smoother and very hard sandal wood seeds strung together with quandong seeds. This tree is native to Western Australia where Betty West lives, and the seeds are very hard to drill. It is unusual to find them being used in necklaces. In the use of seeds from rarer trees such as this, issues of conservation may arise.

Seeds as a general category are known as *mangutji* in north-east Arnhem Land. In the section on colour and rhythm in this book it was shown that both Desert and Arnhem Land artists find red seeds especially desirable.

Quandong tree, Alice Springs, 2001.

Quandong litter and seed, 2001.

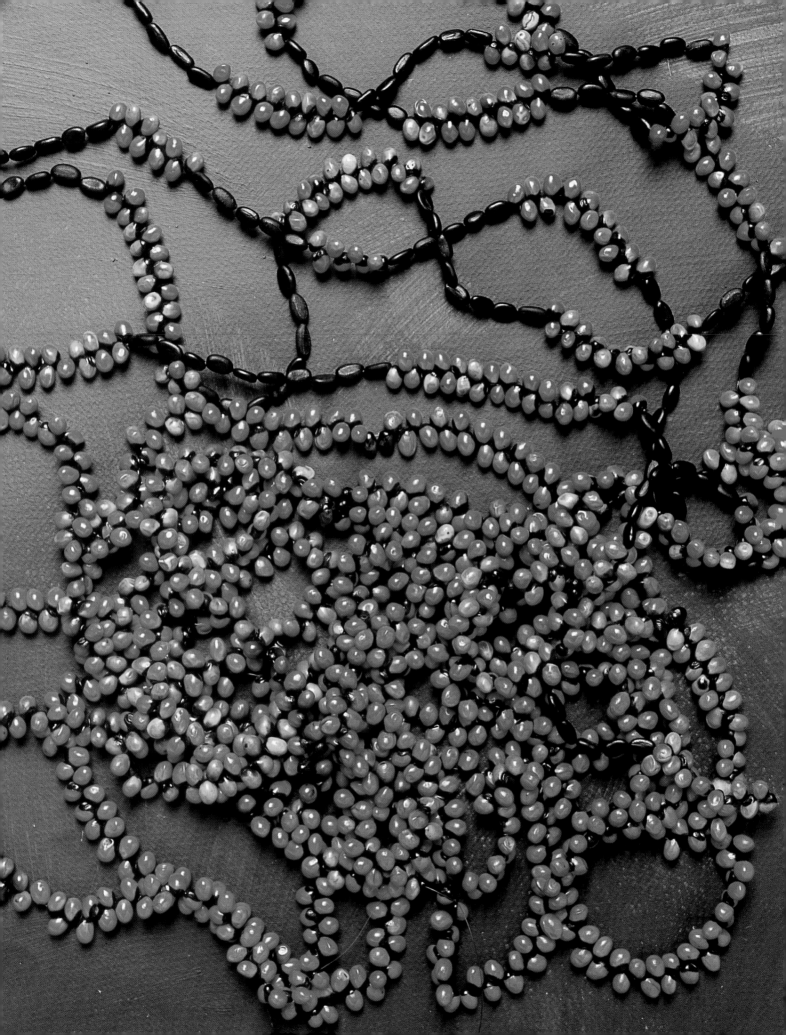

In the past the crab eye or *Abrus precatorius* has been used across Arnhem Land but is not used as much now in necklace making because the seeds are poisonous if ingested. This vine is found in coastal thickets and in rainforests where it climbs over the trees. In Gapuwiyak this often necessitates climbing trees to get the seeds but they are easier to obtain by searching through the leaf litter at the base of the trees or looking for the bright red seeds still clinging to old pods. Because the seeds grip the pods it is possible to find old seeds on a flowering vine. The pods are approximately 4cm long and each contains around six seeds. These seeds average around 6.75mm in length and 5mm in width. They are known as *yiringaning* in eastern Arnhem Land. As mentioned earlier black *Abrus* seeds are rare but have an important connection to land. Women in Yirrkala hold these in high regard and they are only found at a particular site in Yalangbara. Many sites around Yalangbara are important because of their connection to ancestral creators the Djang'kawu Sisters.

The other dominant red seed in Arnhem Land is the red bead tree seed. These seeds are sometimes referred to as 'lolly ones' because of their resemblance to candy in colour and size: they are around 9.5mm by 6mm. This tree is also desirable for its wonderful shade and can grow to be 10 metres tall. It does grow in Arnhem Land but is not a dominant tree in the communities in which most of the women live.

On Elcho Island Margaret WurrayWurray uses these seeds as space dividers in her shell necklaces. Although she does not have a necklace made from these seeds in the exhibition, her comments to the art advisers about the seeds point out important issues of ownership and use of materials. When she uses the red bead tree seeds she does not get her seeds from Elcho Island, they come from her homeland the Marchinbar area in the Wessel Islands.

When Datjin Burarrwanga visited the largest red bead seed tree growing beside a house in Galiwin'ku, he carefully followed Aboriginal protocol and asked for permission to collect some of the seeds. This tree was owned by the man living in the house, who was once the Council Chairman at Galiwin'ku, George Dhangambu Dhurrkay Wangurri (now deceased). The history of the tree sheds some light on its importance to its owners. Dhangambu lived in a house that now stands on the spot where the first missionary to Elcho Island, Harold Shepherdson, known as Bapa Sheppy to the local population, had his first house. Dhangambu said that he and Bapa Sheppy planted that tree. Sheppy brought the tree from the Wessel Islands from the Marchinbar area which is WurrayWurray's homeland. Dhangambu was protective of the tree and when he felt Steve Westley (art adviser) or someone else might want the seeds he said "That's my tree!" in a strong voice leaving no doubt about the ownership and use of its products.[6]

Walinyinawuy Guyula,
detail of necklace (29), 1997.

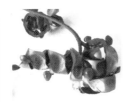

Red bead tree seeds
(*Adenanthera pavonina*) from
George Dhangambu's tree,
leaves from the tree and the
dried pod, Elcho Island, 2001.

Florence Ashley and
Mungulumu Bidingal
collecting crab eye seeds in a
jungle area, Gapuwiyak, 2001.

Bat-winged coral trees have red flowers that appear on the bare branches sometime following the end of winter. Although there is a famous large specimen in a public area in the town of Alice Springs, there are many sought after stands further north. The bright seeds disappear into the sand after falling and a quick excavation with a crow bar or piece of bark will yield them. The same applies to the red seeds of the red bead tree in Arnhem Land.

In Arnhem Land black seeds are usually employed for their contrast and often placed them between other groups of seeds. However in *Art on a String* Minawala Bidingal has produced a work entirely of seeds from the yellow kapok tree, *Cochlospermum fraseri*. These kidney-shaped seeds are strung so they link in pairs nestled next to each other. Minawala calls these *bulyapulya* in Ritharrngu. The large family of wattle trees, the *Acacias* are the source of many of the small black seeds used in the exhibition. *Acacia auriculifomis*, known as *gaypal*, is one that several artists employ.

In Arnhem Land brown seeds come from the ironwood tree, *Erythrophleum chlorostachys* and from a creeper *Canavalia rosea*. When 'raw' the ironwood seeds are green and when they are dried or 'cooked' they turn a golden brown. Artists tend to use these seeds to change direction and rhythm in their work. They are extremely thin, 2mm in thickness and approximately 13mm in diameter. Their long pods hold about eight seeds which Yolngu call *maypiny*. The *Canavalia* plants grow along the edge of the sand dunes making them easy to collect when women are out fishing.

INTRODUCED SEEDS

Most of the seeds in *Art on a String* are native to the countries of the makers with some exceptions. The seeds from these plants, whether native Australian plants or European ones that have been introduced, are still desired. At both Ltyentye Apurte (Santa Teresa) Northern Territory and Ernabella, South Australia on the Anangu Pitjantjatjara Lands, *Eucalyptus torquata* is planted by the school and the church. This tree is from Western Australia but does well in central Australia and has been planted extensively by land councils, in particular Tangentyere council which has a tree nursery. Of the works in *Art on a String* Eileen Bloomfield from Ltyentye Apurte, features operculums which she painted (7). Ernabella artists have used the flower case while Duncan Lynch (30 and 32) uses the same tree, flower case and bud caps attached, which is planted on *his* homeland, to make his necklaces.

Eucalyptus torquata leaf litter with seeds and flowers and operculums.

Creek bed full of bat-winged coral trees, north of Alice Springs, 2001.

Bat-winged coral seeds, north of Alice Springs, 2001.

Eileen Bloomfield, detail of necklace (7), 1996.

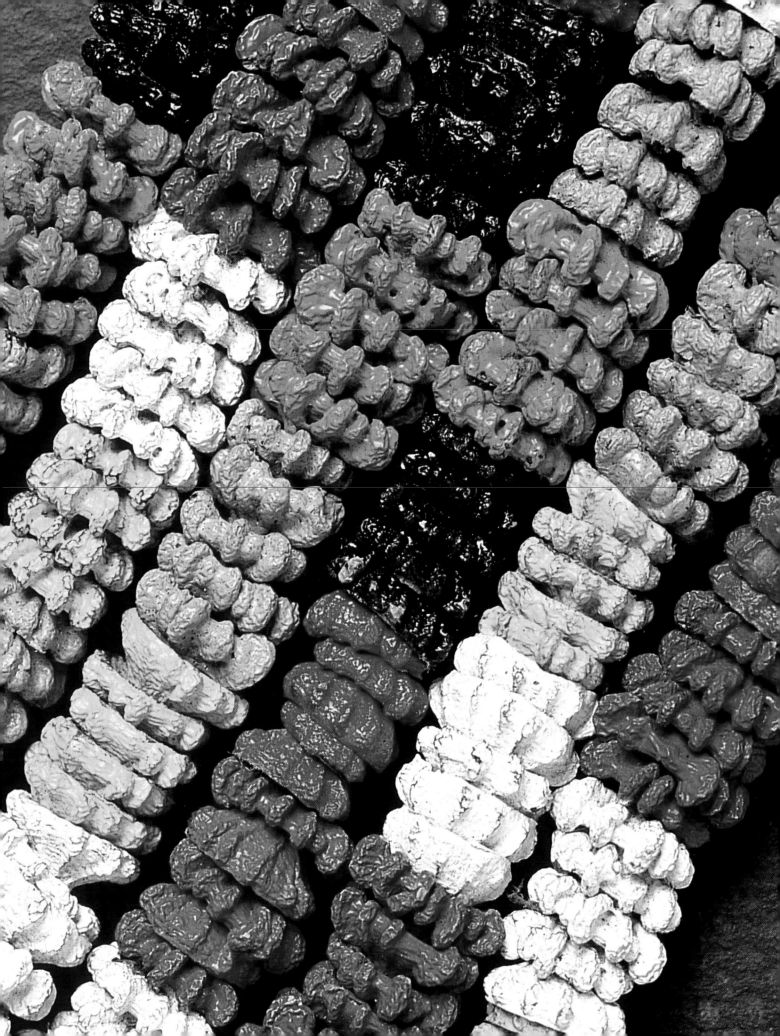

One plant used most frequently in inland Arnhem Land, particularly Gapuwiyak, is *Crotalaria goreensis*. This plant is basically a weed introduced by white people moving into the area. Because it is not a native plant it does not have a name in Yolngu-matha. The shrub produces clusters of pods that turn brown as the seeds ripen in the winter months. These small pods may hold up to eight seeds. The seeds are popular due to their abundance, ease of collection and their great variety in colour. Lucy Ashley refers to these seeds as having 'land rights colours'.

Lucy describes one of her necklaces in *Art on a String* as '*nyumukuniny binana girringgirring*' (small banana necklace). In areas of approximately three centimetres, small banana like pods, which are the anthers from *Senna sp*., are banded by groups of rhomboid shiny seeds. This is another introduced plant, *Senna obtusifolia*. Large groups of small *Crotalaria* seeds make up the rest of the necklace.

⬤ SNAIL TRAIL

In *Art on a String* the largest individual component is the land snail, called *mendung*' in Yolngu matha. There are several types of land snail *Xanthomelon janellei*, X. *pachystylum* and X. *spheroideum*. This animal is a food source but is more often used for fishing bait. Women find it around the base of trees in the leaf litter. In the past these shells have been strung together and used as rattles in ceremonies. In the Donald Thomson Collection housed at Museum Victoria there is a grouping of unadorned snail shells strung on vegetable fibre string. An image of this work and Thomson's comment "Hung around neck of dog while hunting at night", prompted the making of Lucy Ashley's work *Dog Collar*.[7] The collar made for a Golden Labrador contains shells painted in solid colours of red, yellow, black and white. A larger piece by Lucy and her daughter Anna features many patterns in bright colours.

The small shrub *Crotalaria goreensis* with many ripe seed pods,*Gapuwiyak*, 2000.

Small seeds of the *Crotalaria goreensis* in pods, *Gapuwiyak*, 1999. Photo: Roger Bedford.

In addition to the large land snail another smaller snail shell is represented by the work of Beverly Barupa form Maningrida (1). Her work consists of small orange shells approximately 5mm in length from a larger group of snails called *Pleuropoma sp.* known for their tree climbing abilities. These snails also use their colour as camouflage on the bark and leaves of the tree.

● SEA CREATURES

The majority of Arnhem Land communities are on, or have access to, the coast. Animals from the sea are used by artists for their aesthetic qualities and in some cases their strong ancestral links as in shark, turtle and shells.

Shark is the biggest sea creature used by artists in Arnhem Land for the making of necklaces. As discussed earlier, the shark is an important totemic animal and the use of its bone is significant. The vertebrae work especially well as they thread onto string without any alteration. Another sea creature that has long been used in coastal communities is the tusk shell *Dentalium sp.* The long, thin, cone-shaped tusk shells have an opening at the small end and the tips are usually broken off leaving a cylinder for easy threading. Most of the older examples from Arnhem Land in museum collections are of the slightly ribbed variety that women prefer to use. This shell is called *latjin* and most artists use it as a break between other shells or seeds. Elsie Marmanga uses it with red bead tree seeds.

Women sometimes use other white shells in long rows like the dove shells *Euplica scripta* in Wulumduna Gurruwiwi's necklace (57). Maliny Munungurr's work (60) uses facing pairs of small white *Fragum sp.* shells with two bubble shells *Aliculastrum cylindricum.* Mabel Anaka-ananburra uses worn *Nerita undata* shells and Gulumbu Yunupingu uses pearly white 'moon snails' *Polinices mammilla* in her pendant (83).

In addition to white shells there are many other varieties of shells used by the artists in the exhibition. The ones employed most share the common name 'necklace shell'.[8] It is most fitting that the *Clithon oualaniensis* has this name since it appears so frequently in the works in *Art on a String*. In fact the art advisers at Elcho Island Art and Craft have reported extremely long necklaces of five to six metres made only of these shells.

Perhaps the most exotic of shells is found in the work of Wuyuwa Munugurr (71). She has created a necklace on a base of hand-spun Kurrajong string. Spaced around the

Lena Kuriniya,
Rattle (24), 2000

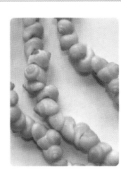

Beverly Barupa, Detail of necklace (1), 2001, Tree climbing snails *(Pleuropoma sp.)* threaded on fishing line.

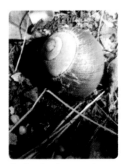

Snail and crab eye seeds found in leaf litter, *Gapuwiyak*, 2001.

loop are blue shells sandwiching beeswax. These incredible blue and green pieces are the operculum of shells. The operculum protects the opening of the shell. In Arnhem Land the blue ones are dominant, in Western Australia they are yellow-green and on the east coast pink and purple. The colour is dependent on the type of algae the animals eat.[9] The blue ones are oval in shape and come from *Astralium stellare*. The only green pair in this necklace is round and called *Turbo squamosus*.

Crustaceans are also present in work from Arnhem Land in the form of *Leucosiidae leucosia*, the crab. Crabs are a favourite food of Yolngu but the freshly cooked crab legs are not strong enough for stringing. Celia Marbin uses parts of the crab legs as separators between her double strands of yellow *Clithons* and pink *Isanda coronata*. Some of the parts are very dark, almost black. All of the crab pieces in the necklace have been found on the beach. They have been buried in mud and undergone anaerobic deterioration causing them to darken. The longer the time in the mud the older the pieces are, the black ones could be up to 200 years old.[10]

Another sea creature found in *Art on a String* is the saltwater tortoise. Gulumbu Yunupingu cuts shapes from the shell and incorporates them into her pendants (83). In the exhibition she has cut out the shape of a shark which hangs at the bottom of her pendant. Ancestral turtles are important in Yolngu beliefs. The shell of the ancestral turtle is called the 'bone' which 'according to Yolngu Rom (Law) holds profound secret knowledge'.[11]

● SKY COUNTRY

Although the land and sea provide the majority of materials for *Art on a String* birds are represented in the works of Rose Mamuniny #2 from Elcho Island. Her distinctive necklaces (46 and 47) contain important ceremonial feathers placed between stark white shark vertebrae. The feathers she uses come from three different parrots; the sulphur-crested cockatoo, red-collared lorikeet, and red-winged parrot, *Aprosmictus erythropterus*. All of these birds are plentiful in Arnhem Land and their feathers have been used in many ceremonial items like the necklace from the Donald Thomson Collection. The red-collared lorikeet is an important Dhuwa moiety bird called *lindirritj*. The red-winged parrot is known as *bilitjpilitj* and the sulphur-crested cockatoo, a Yirritja bird, has many names including *ngerrk*, *dangi* and *lorrpu*. Mamuniny is from the Gälpu clan who are one of the main owners and makers of Morning Star poles and the ceremonies associated with them. Many of these poles have 'arms' of string or hair with a tuft of feathers on the end known as *pul-pul*. These often represent specific sites in the country and groups of people. In two of Mamuniny's works she uses clusters of feathers very similar to the ones used on poles made by her brother David Lakarriny and other male artists from Elcho Island.

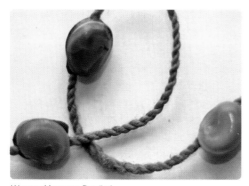

Wuyuwa Munugurr, Detail of
the blue operculum shells
(71), 2001. Blue operculum
shells, beeswax on hand-spun
Kurrajong string.

Barbara Rruwayi, detail of
necklace (45), 2000 and
Celia Marbin, detail of
necklace (44), 2000.

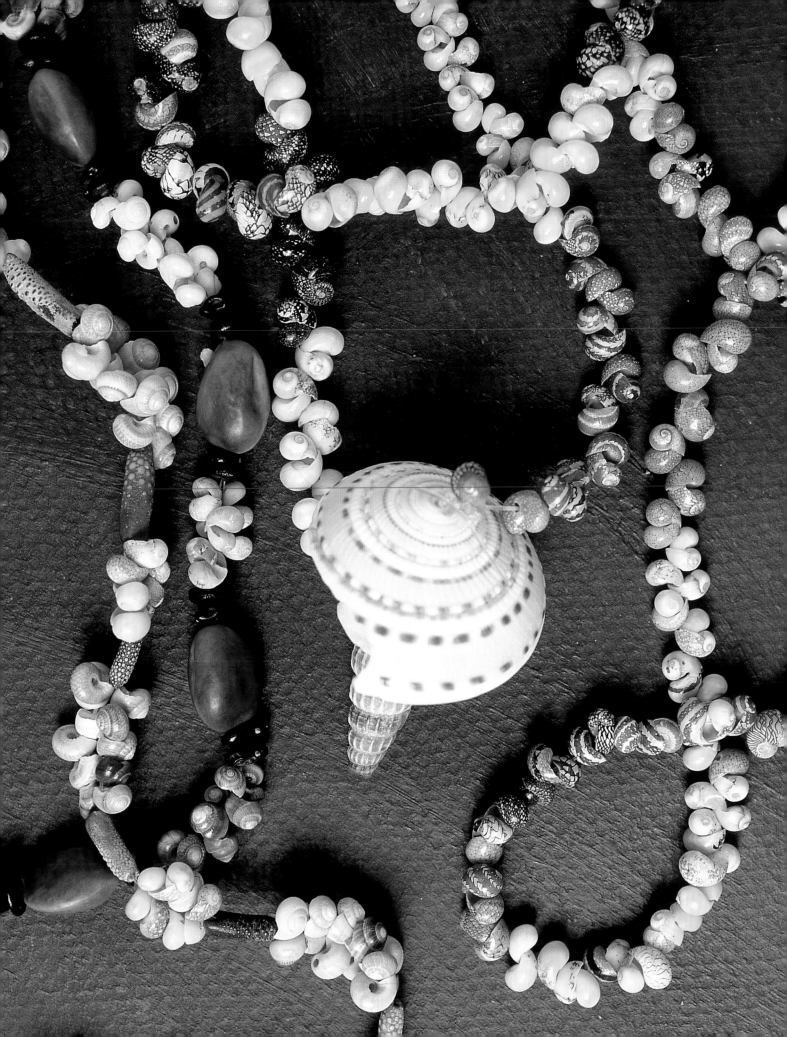

MANUFACTURED MATERIALS

In *Art on a String* most of the mass manufactured materials appear in the threading medium of the works. In the past spun human hair was the primary material used for threading necklaces in the Desert and for some ceremonial items in Arnhem Land. Possum fur string and spun plant fibre string were the other main media used in Arnhem Land. These traditional materials have been mainly replaced by a large group of other materials. As discussed in section 1 many of the choices are based on the particular wishes of art advisers and those who buy the works. In Arnhem Land fishing line is extremely important for catching fish and threading objects. In fact it has made possible the use of some very small seeds that artists would not have been able to thread in the past.

Wooden craft beads are a good substitute for gum fruits and can also be branded with hot wires or painted. Some tiny glass beads are found in the work of Nyinyipuwa Guyula (79). Their scale and colour is very much like that of the small *Acacia* seeds used in many of the works in the exhibition. The other item, which resembles a natural material, is the white plastic holder for cotton buds. Some artists from Maningrida have incorporated small cut pieces of the plastic tubing which holds cotton swabs on either end. At first glance this tubing, which also has ribbing, looks like the tusk shells used in other works. Laurie Bayamarrawunga's work (37) in the exhibition is described by Ian Loch of the Australian Museum as having almost twenty different species of shells including cotton bud holders. The pieces of plastic function in exactly the same way as the difficult to obtain tusk shells.

This section has examined the materials that artists from both regions have used in their work with several objectives. One was to learn about the nature of the materials themselves, where are they found, what they are called and their properties and potential. In this process aspects of their historical use and their connections to the ancestral past provided a contemporary context. Some of the same materials and techniques have been used by both Arnhem Land and Desert people. Although there is much sharing in Aboriginal culture there is also a strong sense of ownership and rights over the materials whether they are from native or introduced plants, or whether they came from the sea, the land or sky.

endnotes

1. S Britton, and B Marika 1996, '[Art is Land], [Land is Art]', *Artlink*, 16(4): pp.16-17.

2. JB Hawkins, 1990, *19th Century Australian Silver Volume II*, Woodbridge, Suffolk, England, Antique Collector's Club. p.132.

3. P Latz, 1996, *Bushfires and Bushtucker: Aboriginal Plant Use in Central Australia*, Alice Springs, IAD Press. p.179.

4. G Wightman, 2001, 'Coffee Tree Bush'. Personal communication to Louise Hamby.

5. L Hamby, 2000, 'Objects Between Cultures: Necklaces from Arnhem Land', *Object* (3/00) pp.28-31.

6. B Westley and S Westley, 2001, 'Red Bead Seed Tree.' Personal communication to Louise Hamby.

7. D Thomson, 1937, 'Ethnographic Catalogue', Ethnographic Catalogue in the possession of Museum Victoria, DT 1217.

8. J Allan, 1959, *Australian Shells*, Melbourne, Georgian House. p.74.

9. I Loch, 2001, 'Blue Shells', Personal communication to Louise Hamby.

10. S Ahyong, 2001, Crab Legs, Personal Communication to Louise Hamby.

11. Buku-Larrnggay Mulka Centre (Ed), 1999, *Saltwater: Yirrkala Bark Paintings of Sea Country*, Neutral Bay, Jennifer Isaacs Publishing in association with Buku-Larrnggay Mulka Centre. p.82.

Gulumbo Yunupingu,
pendant (83), 2001.

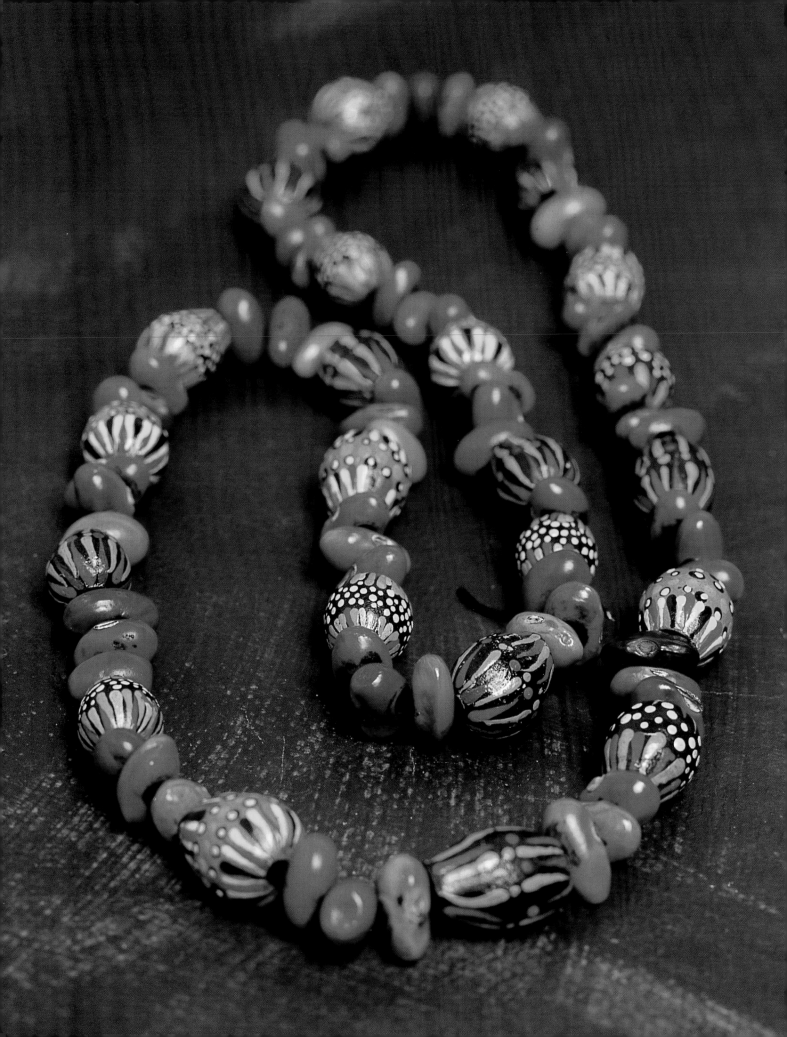

MAKING OF THREADED OBJECTS

"Making necklaces makes me feel happy.

We like to make necklaces."

THIS STATEMENT BY GULUMBU YUNUPINGU FROM YIRRKALA HIGHLIGHTS ONE OF THE MAIN REASONS WHY ARTISTS represented in *Art on a String* make threaded objects. One might think monetary return would be a primary objective but the payment for this work is minimal. The actual making is a time consuming, repetitive process. This is expressed in Gulumbu's summary of the process of making: "We spend hours *ga* [and] hours *ga* hours; collecting *ga* hours *ga* hours; making holes *ga* hours *ga* hours; threading *ga* hours *ga* hours. At the end—pay, but not enough money for necklace. They take hours, just a little bit of money." Regardless of the many hours, necklace making is an activity that women enjoy. It is an important social process involving women and children, some not making necklaces. Some women may occasionally work by themselves but generally they are found in groups sitting around the fire or under a shade tree. This style of 'studio' demarcated by a plastic tarp or sheet is more adaptable to playing children, running dogs, and others joining in the activities. Threaded objects are very portable; they can often be carried in the pocket or bag. As a consequence unfinished work travels around with women whether they are in their home camp or have gone to the opposite side of the continent.

Panjiti McKenzie sums up the way of making necklaces which applies equally to both the Desert cultures and to Arnhem Land: *"Tatu green one tjuta, piltiringanyi munu wayaku pauni, munu alarni, munu walkatjunanyi malangka."* "[We get] lots of green gum fruits, let them dry out and then 'cook' them with a wire to open them [make the hole] and then later put the design on them." Each artist has their own way of making as is evidenced by the interviews, but the broad process is similar. The 'raw' materials are collected from country, they are sorted, dried or 'cooked' by boiling and then pierced and strung. Or they are 'cooked' by being burnt with hot wire to 'open' them, then perhaps painted or branded and strung.

Alison M. Carroll,
necklace (67), 2001.

In both Arnhem Land and the Desert most necklaces, bracelets, curtains and other items are made for sale. The majority of the time these works are made by individuals but in other cases there is more than one maker. Multiple authorship is quite common but often this is not recorded or in some cases not known by the people buying the work and recording the information. Gum fruits may be painted by one artist and threaded by another. Materials are sometimes collected and shared or bought from others. When the work is taken in to art centres or shops to be sold, another person may deliver the work for their relatives. Sometimes as a consequence that person's name is placed on a tag or recorded as the maker.

Making small threaded items, even though the amount of money is not large, is a means of making quick money when it is needed. Women who make these items have an understanding of the market for their work. They know the majority of the eventual buyers and wearers of their work are non-Aboriginal people. Artists may wear items they make, and that are destined to be sold, for a short time. Aboriginal people give necklaces as presents to one another and to their white friends, often with the expectation that they will be sold. This practice is like giving someone a present of money. In the Desert the same type of thing happens with woodcarving or *punu*, (there are small carvings in Niiningka Lewis' bracelet). In Arnhem Land the equivalent would be baskets. Speaking for herself and the women she works with in Arnhem Land, Gulumbu Yunupingu said: "You make us proud when you wear them. They make you look beautiful". The artists take pride in their work and enjoy seeing people wearing it.

There are influences in both areas on artist's work by art advisers and other people they deal with mainly in terms of the type of threading material and length of the works. One of the reasons extremely long necklaces—which may relate to ceremonial practice—are not made frequently is they are not bought by dealers. Until the late 1990s hair strings threaded with bat-winged coral seeds, 2.5 to 4 metres long, were being made by both men and women. They are infrequently produced today. In Arnhem Land some women still make long works. Regardless of what the threading material or length may be, the individual styles of artists are not determined by someone else as evidenced by the variety of work in *Art on a String*.

Marrnyula Mununggurr, Mundul Wunungmurra and children going collecting for seeds and shells, Yirrkala, 2001.

Women take advantage of containers left behind by others when out collecting items for threaded work such as this plastic Coke bottle found on the beach, Yirrkala, 2001.

The making of contemporary threaded objects is grounded in past practice. Some materials and approaches are the same and others are relatively new due to the availability of different tools and materials. Artists have various reasons for using particular materials for the sub-structure, the threading material, and the objects that form the composition. The basic procedure for the making of necklaces in Arnhem Land is similar to the Desert, with differences arising in the variation of materials. Production stages include the collection and storage of materials, preparation, drilling holes, stringing, completion and storage.

The collection and preparation of materials are the most communal of all the steps. Although these are labour intensive and time consuming, they provide an opportunity for mothers and grandmothers to teach children about these processes. Whether they are collecting shells from the beach or tiny seeds from the bush many people become involved in the process. Various containers are used for this process; sometimes a specific item obtained on a trip, but more often the item employed is what can be found at the place of collection. Plastic drink bottles are very popular for carrying seeds and shells, or simply tying the objects into a knot in your dress or putting them in your pocket. Preparation of materials usually involves some form of cleaning, washing or removing unwanted portions or in the case of shells, removing the animals. Drilling holes can be as simple as spearing a small young seed onto a needle or as complicated as burning holes in very tough seeds or drilling into hard shells. In Arnhem Land most women use sewing needles for the threading of small objects, or thread without a needle using their hands for larger objects like land snail shells. In the Desert the threading of materials is similar, particularly since large bodkins have been made available to women for their basketwork.

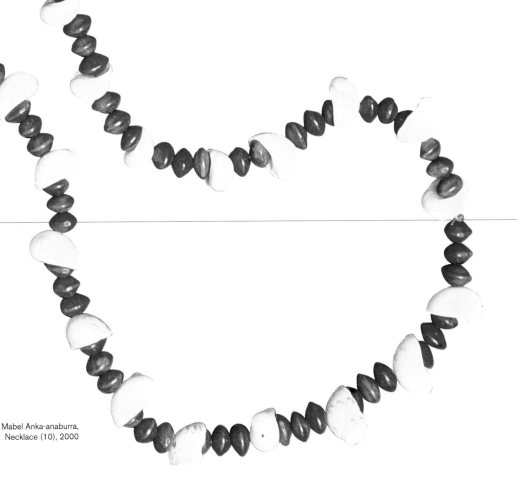

Mabel Anka-anaburra,
Necklace (10), 2000

Four types of holes (burnt,
pierced, natural and drilled).

Necklace Making

Date: May 2001, People: Leonie Campbell and Diana Young, Place: Alice Springs

(all references to bean tree seeds in this interview refer to bat-winged coral)

DY Tell me about those little black seeds you use for your necklaces.

LC I stopped making necklaces for 10 years and started again in 1997. I saw the pods hanging down from the trees at Morris Soak, Tangentyere Council must have planted them, and I knew the seeds would swell if I soaked them and then I could sew it. I take 'em off the trees, take them out the pods sort 'em out, then you got to boil them to get 'em soft, then reboil them if they don't get soft, and I sort the soft from the hard before I can make a necklace. When you're sewing it your fingers go nice and smooth [from the oil in the seeds]. It was the Mission Block told me to do them on tooth floss—not waxed though 'cos the wax all comes off and builds up. I boil them in water and let them soak for a couple of days to get them soft. They go hard again when they dry. They swell up when the water's in it.

I've got one of these [seed from Morris Soak trees] that's in water in the sink. But it's starting to grow and I'm gonna plant it and have my own tree. If you let em soak in water longer than you should sometimes they go darker. All the trees mightn't be the same, they are the same seeds but different trees might have some darker seeds than the others. And, if you get them when they're green you'll get all green, green and brown you know all together.

DY Do you ever use them when they're green?

LC I did make one necklace that was green, I didn't like the colour of it, but I still sold it!

DY Would it have stayed green?

LC It goes dark green, from light to dark… you can see the green and the brown in it. When it dried it was just little green, it would have gone from the light green to the darker green as it dried.

DY Where did you sell that one?

LC I think it would be at Mission Block down the Gap, cos they don't sell 'em in town now, to sell it you need to go to Mission Block to the store in the Gap Road and they put them out in the store later and they sell them from there. There are about 5 or so shops in town I sell them to.

DY When you started making those was there anyone else in town making necklaces?

LC Yeah, a cousin of mine, Hilda Swan, she used to make em, that's where I got the idea from. About '76 I started making necklaces.

Leonie Campbell, detail of
necklaces (17 and 19), 2001.

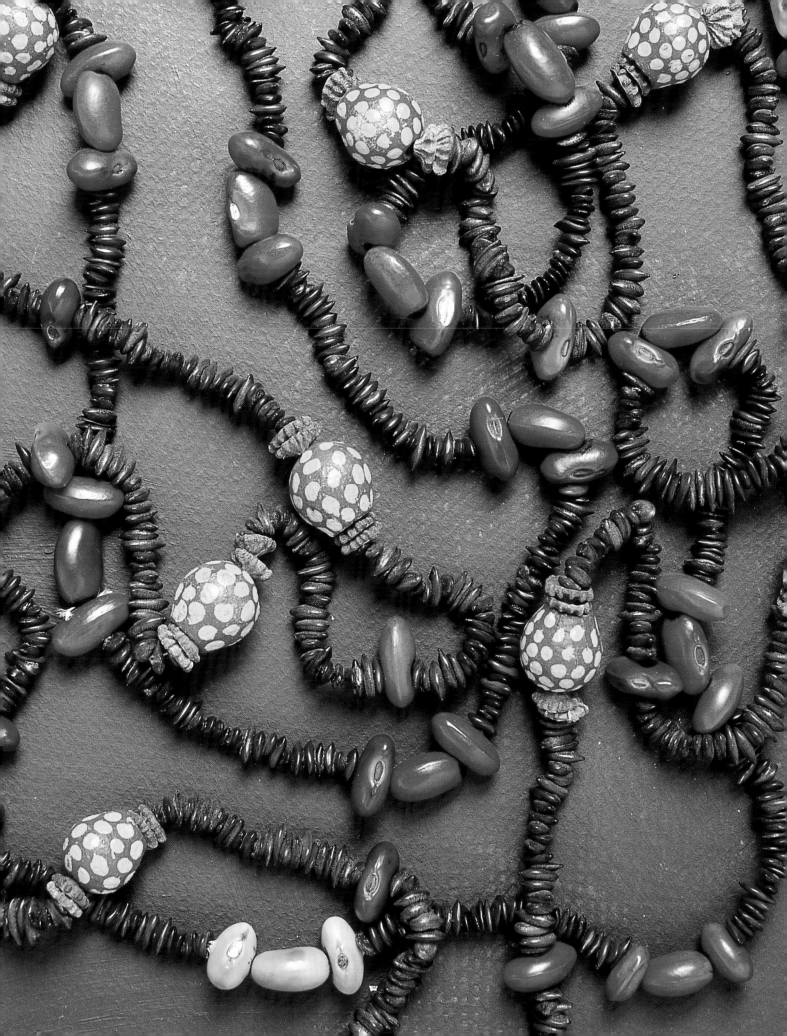

DY What was she making them with, bean tree seeds (bat-winged coral seeds) or...?

LC We didn't have those bean tree seeds then we just had those little round black ones, used whatever we could. They were completely different from this. The art gallery we went and sold them to is still sitting there today. Near the Land Council lawn near Kentucky [Fried Chicken]. Paul Achee's before he bought it. Some other person was working there then. I don't know her name but she always bought what I made. But what I made in those days was different from this. They didn't know anything about these at that time. She used to ask me to mend other people's necklaces. The highest I ever got for them in them days was $8. I don't remember burning any holes, what I do now is burn holes through these ones [bat-winged coral seeds]. You get a blunt wire first then a sharp one. And to do it long ways is harder. you need a long thin wire, you don't make a big hole in that end cos the other end only got a small hole there. a lot of people used to do it with a big wire, thick wire, but I like doing it with thin. Them old girls in the bush stab at them [laid on a flat surface].

DY And you warm the wire up on the stove?

LC Mmmm. To make the hole length ways they've gotta be thick because if they're not they can easily crack, cos they do get soft, you can't have anything to hold it, you know, like if you put it through you gotta do it with your fingers otherwise something holding it can be tight and then when you're holding it, it can get squashed. I did that one day and it just cracked. So I just hold it with my hand and a tea towel and burn it through. I've burnt myself that many times [laughs]. I've got an old tea towel and the tea towel's all burnt from the wire, just hope it don't catch on fire.

DY Where do you collect these bean tree seeds from?

LC I've had some given to me and I did buy half a bag once from CAAMA [Central Australian Aboriginal Media Association] 'cos they liked what I did too and they were buying them. Some of those seeds are nearly black. I got a whole bag from my daughter in Mt Leibig. With the little gum caps you break off the top and the hole is automatically there. Those little round black ones you've got to get the right angle [for the hole] so that they're all level otherwise they all stick out [at odd angles].

Judy Davis,
Necklace (49), 2001.

62

Then I didn't do them for so long. It's only when I get bored I think I do it, or if I need the money, something for me to do. I'm gonna do one long one and put it on my wall one day. The shop that you got this necklace from, they measure it, and if it's not long enough you won't get what you need, you know. They said they like it long so people can put it round their neck like this, just put it over [your head] and I've made a design where the yellow comes like that and the yellow hangs down here somewhere (17). And I said 'Oh well that's long enough'. And I was told at another shop if I do go for gum nuts then I have to make it so long and then I get the same price.

DY When did you start doing the painted gum nuts?

LC Last year or beginning of this year I just thought I'd give it a turn. Give it a go. I'm not into it mainly. A lot of people do paint the seeds these days but maybe now and again I'll have a go at it. The little gum caps they're more yellower maybe they've gone dark from being wrapped up. This necklace had red ones gone dark now. Different colours from different trees. This is almost black this one here [dark bean tree seeds] or a dark purple.

Leonie Campbell lets the finished necklace dry in the sun on her window sill and eases up the slack in the tooth floss as it dries to get rid of gaps so that the whole ends up tight on its string.

STORAGE

In Arnhem Land the favourite means of storing necklaces while working on them is a hand-fishing reel. Fishing is an important activity and almost everyone has a reel—the reels performing double duty reeling up necklaces and reeling in fish. When the necklace has reached the desired length it is tied off, or if it has more than one strand, looped and then secured. There is a difference in storage in the Desert. Here artists are making shorter necklaces which can be finished more quickly. Painted beads can be stored on wire before stringing. When a necklace is finished the maker might wear it for a little while and then sell it or give it as a present. The following sections detail some of the peculiarities of making threaded objects with different materials from the Desert and from Arnhem Land.

STRINGING

Central Desert artists with relatively few materials, have become inventive in their methods of stringing, especially of bat-winged coral seeds. The necklace from Finke collected in 1931 has these seeds pierced and strung length ways, a trickier manoeuvre than a hole through the shorter part of the seed (see Cora Campbell and Bessie Liddle). At Santa Teresa, formerly a catholic mission, artists have used bat-winged coral seeds strung long

Fishing reels are essential items in Arnhem Land and are often used to store threaded works as they are being made as seen in this reel with seeds owned by Ruby Jin-mangga, Maningrida, 2001.

Half-painted gum fruits by Nungalka Stanley stored on fencing wire, Anilalya Homelands, Anangu Pitjantjatjara Lands, 1997.

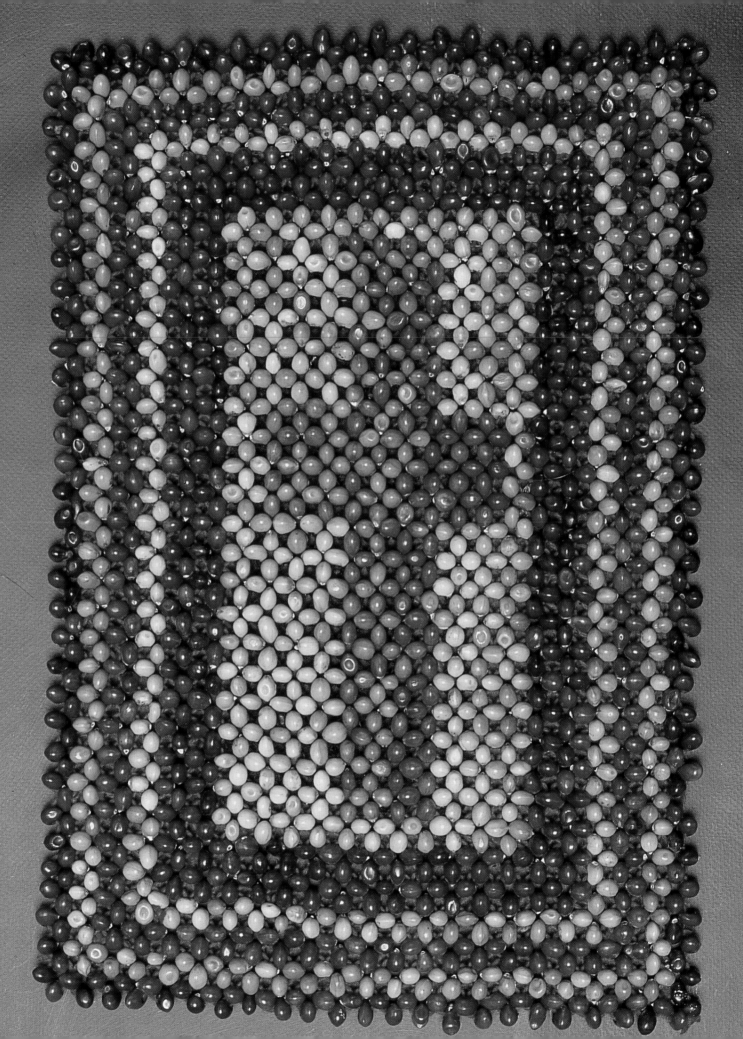

ways to make rosary beads. Making the seeds into flat planes to form mats or bags or belts is a skill that a few artists are known for. That is, other artists know who has this skill even if the work will end up in a shop without the maker's name attached. The path that the threading material makes, passing through each seed more than once, is an important part of the pattern, even if only the artists know how it fits together. All the bat-winged coral seeds are held upright by the string. Martha Palmer has used this matting technique in her necklaces by having two threads parting and then coming together through the same seed again. Bracelets too, with bat-winged coral seeds strung at either end of gum fruits or quandong seeds (Daisy Kanari and Niningka Lewis) are formed using a deep 's' shaped meander of thread, a pattern used in batik by women in South Australia.

In Arnhem Land the threading of seeds in different planes is a device also used to create different rhythms in necklaces. Djupuduwuy Guyula alternates the planes in her all-black necklace (75) and Walinyinawuy Guyula threads them in their lengthwise direction, a difficult task (62). The matting technique of stringing is not used but artists often use two or more strands that are independent of each other that come together through a seed or shell and then continue on. Elsie Marmanga does this in her combination of red bead tree seeds and tusk shells (9).

GUM FRUITS

In April and May 2001 the red Central Desert was covered in green growth after a year or more of unusually heavy rains. This was one of the reasons that no one in the north of the area was making necklaces at that time. At Ti-tree, Nola, who is Anmatyere, said that the gum fruits were "all green now" and therefore unusable. Further south though, Pitjantjatjara, Ngaanyatjarra and Yankunytjatjara artists were using the green fruits but letting them dry first. It is for this reason that many of the works in *Art on a String* are from artists based in the north of South Australia and Western Australia.

When the gum fruits are dry they harden and turn a greyish brown. Queenie Adamson's necklace (70) of bat-winged coral seeds, is the only piece of work in *Art on a String* with unembellished gum fruits. This reflects the rarity of such a piece now when most artists wish to use paint or poker-work (branding) on the fruits. In the early 1980s many strings of unpainted gum fruits were produced especially in the Amata area of the Anangu Pitjantjatjara lands, and sold. In Arnhem Land the mostly unembellished works are those produced with grass stems.

Maudie Raggett, Mat (23), 2001.

I learned from mum. She been doing it long time. You start from the middle [of the mat] and go round and round till finished. Lots of work. Use hot wire. *Inernte* [bat-winged coral seeds] trees grow this side of Pupanya [Papunya]. After winter go out and get them. [The seed colours are] maru [black], tjulkera [yellow], tataka [red]. Orange—no word in Luritja.

Maudie Raggett talking about making mats from bat-winged coral seeds.

Green gum fruits, considered to be 'wet' by artists, freshly collected in a red flour bucket, near Ernabella, 2001.

Making Necklaces with Gum Fruits

Date: May 2001. People: Agnes Petrick and Diana Young. Place: Harts Range.

AP I'm Western Arrernte but my grandmother was Pintupi and I speak Luritja.

DY How long have you been making necklaces?

AP Since about 1992. Big mob used to do it [here] and then I learned from them. Painted ones only, then later on I did those [branded ones]. You put a hot wire through the gum nut to open it. We use knitting wool. Sometimes we double it up. We tried fishing line but it was too skinny.

[The bean tree in the garden of her house is a brown one and the bean tree that Agnes Petrick grew from seed and planted over the road the white one according to the respective colours of the bark on the trunks].

We look at the trees here in the garden. We look out for flowers. No sign of flowers now. There's a big mob of them trees down that little creek. No gum trees only bean trees. We collect buckets of each colour separately, black ones, yellow ones, orange and really red ones.

DY Which colour is the commonest?

AP Orange. We used to put varnish on them big ones [gum fruits]. I put little bit of hair oil on my hand [and rub it into the bean tree seeds] makes them real shiny.

GRASS STEMS

Until recently, grass stem necklaces have been an article that has not been sold commercially. Gapuwiyak and its outstations is currently the place where the majority of these necklaces are made. The grass is difficult to see in the flood plain by the river where other grasses make a sea of green. The plant is pulled from the ground and the outer leaves, roots and flowering pieces are removed. The next stage is cutting the hollow stems into small pieces about a centimetre long. Djupuduwuy Guyula pointed out the importance of the way in which the grass is cut. Using scissors or a chopping motion with the knife damages the grass causing it to splinter. Djupuduwuy scores around the stem with her knife and then snaps off the stem. Before the threading can begin the string must be prepared. Traditionally this has been hand-spun vegetable fibre from Kurrajong. The _nanarr_ necklaces for this exhibition are all threaded on hand-spun string. The individual cut pieces are added to the string by sliding them over the string, no needles. The finished multi-stranded necklace is actually one long string. The string can be from three to five metres in length. The length is tied and looped the appropriate number of times to produce a thick choker-style necklace.

 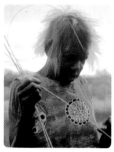 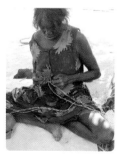

Djupuduwuy Guyula collecting grass (*Leptoehloa fasca*), Buckingham River.

Ngangiyawuy Guyula gathering grass (*Leptoehloa fasca*) for making *nanarr*, Buckingham River, 2000.

Djupuduwuy Guyula scoring around the grass stem with a knife, Buckingham River, 2000.

Djupuduwuy Guyula spinning the Kurrajong fibre to use for the threading of the grass stem pieces, Buckingham River, 2000.

Djupuduwuy Guyula threading the grass stem onto the long string, Buckingham River, 2000.

Duncan Lynch, detail of necklaces (30 and 32), 2001 and Anna Malibirr, detail of necklace (4), 2000.

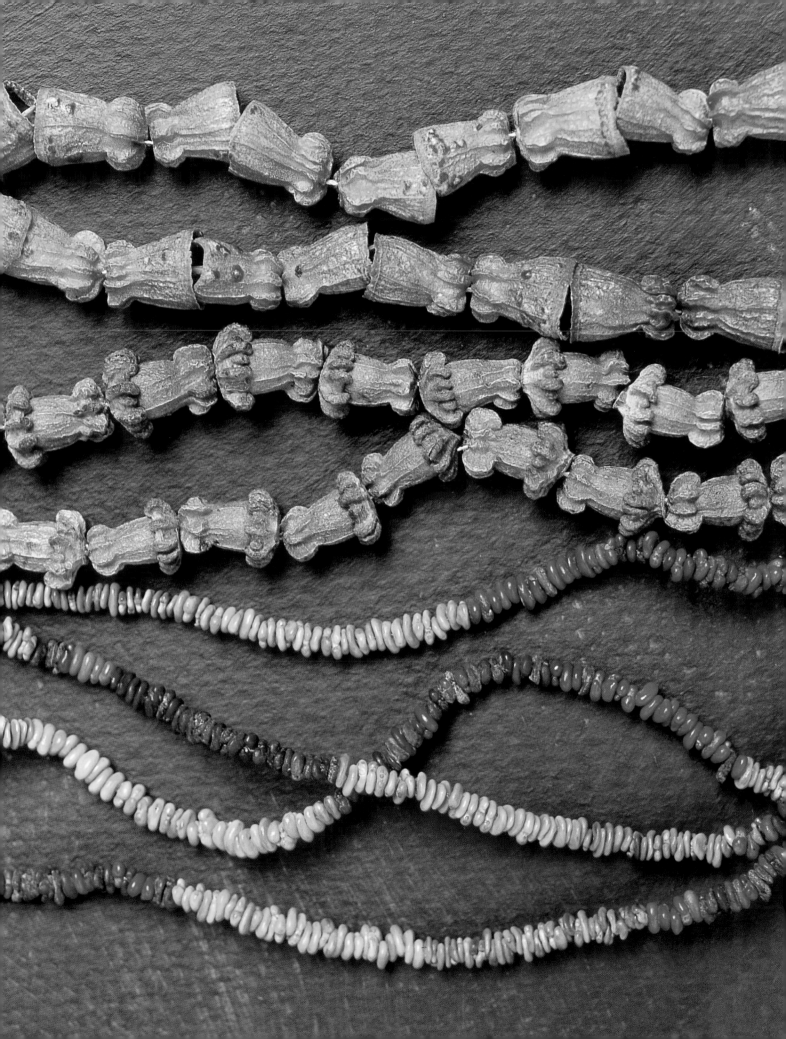

CROTALARIA

The making of tiny seed necklaces, particularly with *Crotalaria goreensis*, is more characteristic of inland communities like Gapuwiyak. Whole pods are pulled off the shrub and brought back to camp. Separating the seeds into colours is a time consuming task because of their small size. The average size of a seed is 1.5mm thick, 2.9mm wide and 3.7mm long. If they are going to be used immediately they may just be piled up on the tarpaulin that people are sitting on, or put in a small tin for later use. The seeds are so small it would not be possible to thread them without the use of a small sewing needle and a fine 'string'. The string is usually fine fishing line though sewing thread is sometimes used. The artist spears the seeds in the order that she wishes for them to be on the needle; impaling several before sliding them down the line. Styrofoam meat trays or the lids of large tins are the surfaces that the seeds are spread upon. The foam trays provide a good surface to push the needle into. As the necklace grows it is pushed down the fishing line and slowly rolled around the reel. The reel and remaining line serves as storage for the necklace in progress, providing a secure ending. The necklaces made using this method are usually one strand in Arnhem Land, though one may sometimes get a double threading. They are also some of the longest produced necklaces reaching up to five metres.

BOILING

Necklaces made from *Crotalaria* and other small seeds differ from larger and harder seeds in the hole-making process. It is not possible to thread them directly onto a needle unless the seeds have been prepared before hand. One method used by women in Arnhem Land and Leonie Campbell in the Desert, is to boil seeds to soften them prior to threading them together. In the case of some seeds like crab eyes (*Abrus*) the boiling can alter the colour of the seeds depending on the amount of time in the hot water. A factor that features for 'saltwater' people (those who live in communities located on the coast) is the type of water used for the boiling. At Galiwin'ku artists who dye fibre and those who boil seeds to obtain different colours, know the importance of saltwater. Valerie Bukulatjpi explained the fact that boiling seeds in water from the ocean made them brighter. If they cannot go to the beach to collect the water they sometimes substitute a package of salt from the shop. Seeds can be thought of as 'raw' and 'cooked', the 'cooked' ones are ready to use. For other seeds like the coffee tree bush the colour does not drastically change but may darken. Seeds that have been 'cooked' not only soften but also swell. As they dry they shrink back to their original size.

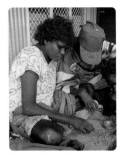

Lucy Ashley and her son
Ronson sorting *Crotalaria*
seeds, Gapuwiyak, 1999.

String and Grass Stems

Date: May 15, 2001. People: Ngangiyawuy Guyula and Louise Hamby. Place: Gapuwiyak.

LH Can you tell me about the _nanarr_ [grass stems]?

N *Nhina napu ga dhawupmara.*
We begin by setting [it, grass plain] on fire.

Manymak ga rulba ngga lithan ga wandirr napurr ga yikiwuy batna wo (retja)
Good, then we wait a bit until it gets dry then we go and pick up a knife.

Mithunuū dhawarr
We cut it.

Ga buyu'yuna napurr ga¯bilin
Then we rub it on our thighs.

Djudupnha nhirrpan ga napurr ga galkana¯dhawar
It goes in now, we put it into a container

Mithun¯ dhawar yikiy dhiyal ngorra
It lies there after being cut with a knife.

Raki nherrpan matha ga rulbang ga bulu
We put the string on our tongue, then wait, then do it again.

Bitjan bili napurr ga munguy' buta'yun¯raki butja matha marran rulwangmaran
This is how we always put the string in our mouths, put it down for later.

Ga bata nhanngu napurr ga
And we are experts at this.

Mithun napurr ga ngunhal dhudi yindingurr
We cut it at the big lower end.

Galkin garrbi'yundja dubukna
Then next we bind it and pick it up.

Gurrukama dutj lithanmaran banda ngorra
And take it back and lay it out on a stone to dry.

Räwakthirr ga bala napungga mithun
When it has dried out we cut it in the middle.

Mithuna¯yikiy dhiyal ngorra
We cut it with a knife and it lies there.

Wandirr ga budju'yun¯dhawar
Then we hurry to rub it on our thighs.

Bala raki nhirrpana raki nhirrpana raki nhirrpana yän warray
Then we make lots and lots and lots of string.

Dhawar matha rulbang
And that's the story.

In the Desert women make holes through bat-winged coral seeds with wire heated in the fire. Pitjantjatjara women in the Western Desert term the practice of burning the holes, '*alarni*'. Burning the opening like this is also called 'cooking' the seed by artists in both Arnhem Land and the Desert and imparts, especially to the bat-winged coral seeds, a pungent smell that lingers for months. All seeds in the Desert are opened using a hot wire.[1] The exact method varies, stabbing at the seed placed on a block of wood, making a burnt hollow for it, holding it and burning your fingers. 'Raw' and 'cooked' are terms used also by Arnhem Land people. They can also be thought of as ripe and unripe. The terms in Yolngu-matha are *diku* (unripe, raw, uncooked) and *borum* (ripe, cooked).

In Arnhem Land burning is used mainly for seeds that are very hard like the matchbox seed. The preparation of the matchbox seeds can start at the beach where they are found. The elimination of salt water scum and small barnacles from the seeds is the first step. Nonggirrnga Marawili explained to Louise Hamby if they were at the beach the women would use pumice (called *ngarru*) which washes up on the beach. She said it was like steel wool which they would use if they were in town, but before steel wool was available they used *ngarru*. To make the reddish-brown seeds shiny they would oil the seeds. A hot wire is used to burn holes through the seeds. Nonggirrnga demonstrated the technique. She first made a fire and later took a few coals away. She placed these beside her and put the end of a wire in the fire. In order to keep the handle cool she placed some sand over it. She then placed the seed on a flat hard surface to start the process. She pushed and turned the hot wire into the seed. It sometimes took three or four times of heating the wire to burn through the seed. Nonggirrnga Marawili did this until she burnt her fingers and her daughter Marrnyula Mununggurr took over. The same method is used for red bead tree seeds.

The hot wire method is also used when artists use small branches of the pipe tree *Scaevola taccada*, to make beads. In Yolngu-matha the term is *lunginy*; the same term refers to the tree, the beads, and smoking pipes. When artists cut the pieces of wood the inner timber is quite soft and pale and looks like compressed foam. This is easily removed with the aid of the hot wire. In *Art on a String* Lucy Ashley's work (66) contains beads of *lunginy* painted with acrylic.

Cleaning a matchbox seed with a piece of natural pumice washed up on the beach, Yirrkala, 2001.

The wire used for burning holes in the seeds is being headed in the fire with sand piled around the portion held in the hand, Yirrkala, 2001.

The hot wire is beginning to burn through a matchbox seed, Yirrkala, 2001.

To make sure the wire has penetrated, it is often picked up and pushed through the seed, Yirrkala, 2001.

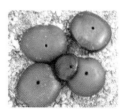

A group of matchbox seeds and one *Mucuna gigantea*, Yirrkala, 2001.

PAINTING

Once gumfruits and other large seeds have been 'opened' with a hot wire at their stalk end so that there is an opening right through them, they can be painted. Painting of fruits and seeds is often done by sticking them onto the end of a piece of wire or a match and planting them in the ground like so many heads. The top half of the gum fruit is painted and left to dry before the seed is turned upside down and the process repeated. Painted or half painted seeds are stored on pieces of fence wire. This makes them conveniently portable as such work is kept with the artist wherever she goes.

SHELLS

The making of shell necklaces presents different requirements. Collection can be somewhat challenging when the shell you want walks or digs itself away from you! The collectors also have an added nuisance of insects if they are searching for shells that live around the roots of mangroves. A major step in preparation is the removal of the animals living inside. They are first boiled and the contents picked out with a needle. The holes are pierced with a safety pin or small nail against a rock, too much pressure results in a broken shell. The same boiling or 'cooking' procedure is followed by women who use the vertebrae of shark. They use mainly the smaller black-tip reef shark known as *bul'manydji*. The young sharks come into the shallow waters of the mangroves where they are easily speared. They haven't had time to learn the habits of the Yolngu fishermen who desire the young livers to eat. The parts of the shark desired for necklaces are boiled until all flesh falls away and the white discs are left. They are then easily threaded onto a line through the natural hole in the centre.

Some artists sort the beautifully patterned necklace shells in plastic drinking cups and tins forming a large palette of colours and pattern. Others keep an assortment in containers. The most common method of threading is using fishing line, due to the weight of the shells. Single threading is the most common but some artists do double, triple or even quadruple threading. The individual strands are brought together usually through one item, either another shell or seed, which sets up a rhythm in the piece. Some artists divide their work into broad bands of colour by changing the pattern or colour of shells, like the long pendant by Barbara Rruwayi, which ends in a large sundial shell with a tall conical one extending from it. A new approach to a broad band of colour and shells is the work of Wuyuwa Mununggurr and Gulumbu Yunupingu. Strands of string are left unadorned and then *gundjuy* (beeswax) is moulded onto the string or in Wuyuwa's case fluorescent nylon fishing line. Shells are then pressed into the wax that hardens and holds them in place. Yolngu have used beeswax for centuries to attach

Group of shells on the beach with animals still inside, Elcho Island, 2001.

An unfinished necklace of Wuyuwa Mununggurr on fluorescent fishing line resting on some of the materials she uses in her work, Ski Beach, 2001.

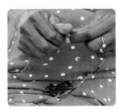

Wuyuwa Mununggurr moulding beeswax onto the fishing line, Ski Beach, 2001.

Merrkiyawuy Ganambarr threading necklace shells onto dental floss, Ski Beach, 2001.

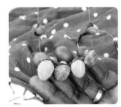

Wuyuwa Mununggurr holding shells attached with beeswax onto the fishing line, Ski Beach, 2001.

spear points and to make pendants. Wilbur Chaseling, the first missionary at Yirrkala in the 1930s, collected two beeswax pendants on string studded with *Abrus* seeds. Although the Chaseling pieces are large chunks of beeswax, 100mm in width, the technique of making was the same as that of Gulumbu and Wuyuwa who live in Yirrkala now.

For shells with pointed or spiralling tops Gulumbu Yunupingu uses a file to wear away the point thus leaving a hole for the threading. She also uses the file to make holes in different positions depending on how she wants to string the shell, point, bottom or middle. She also employs the file to cut small shapes from scallop shells *Amusium pleuronectes* in her pendant in *Art on a String*.

This chapter has examined in detail the methods by which artists actually produce the work not only in this exhibition but also in other similar pieces. General practices are common to both such as multiple authorship and knowledge of both their own materials and the ways of the white art marketing. Processes of making vary in the different regions often related to the type of materials available and cultural background and practices. A few artists employ some common practices, such as boiling seeds and using the hot wire. Major differences occur in the use of paint as a means of embellishment. This practice is a dominant one in the Desert whereas in Arnhem Land the pattern and design occurs either in the materials themselves or in the arrangement of the objects. Overall *Art on a String* presents an exciting view into a world of contemporary practice that has been neglected.

> *"Important for me and miyalk [women], skills ga [and] talent ga knowledge. Important for all miyalk all around Australia."*

Gulumbu Yunupingu May 2001, Ski Beach, Arnhem Land, NT.

endnotes

1. This process is detailed in June Napangka's 1983 Warlpiri book, *Yinirnti-kirli: A Photo Book About Making Necklaces from Beans*, Walpiri Culture Series, Yuendemu, NT.

Martha Palmer, detail of
necklace (15), 2001.

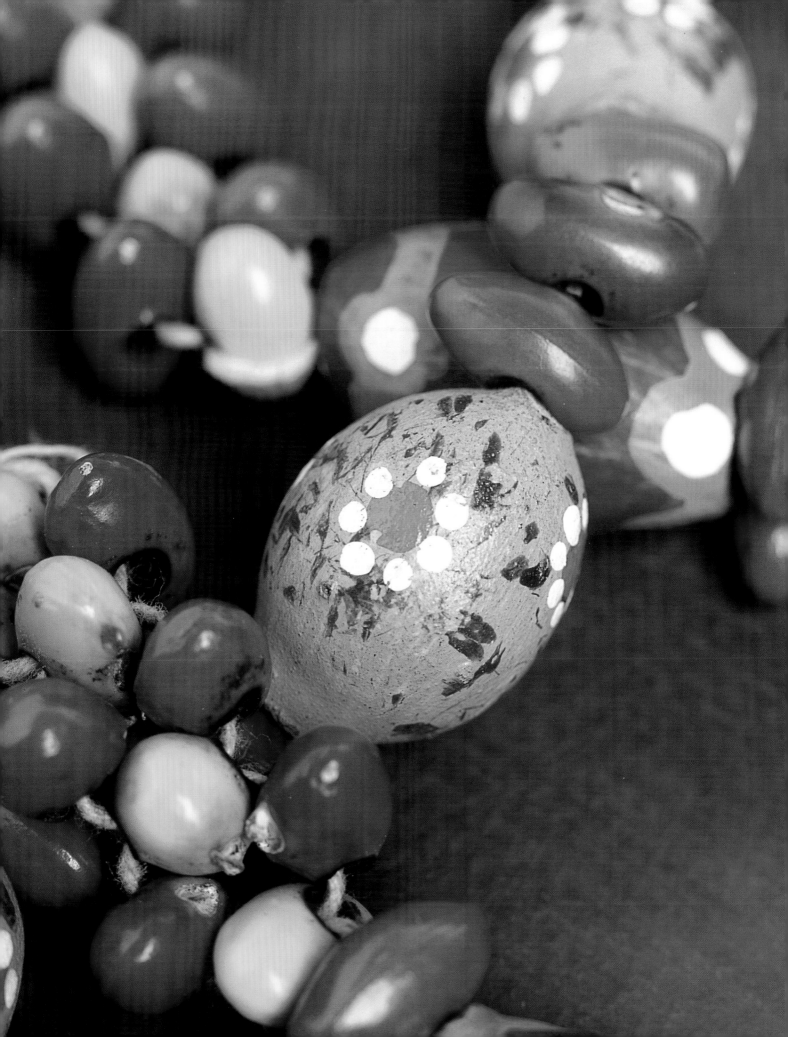

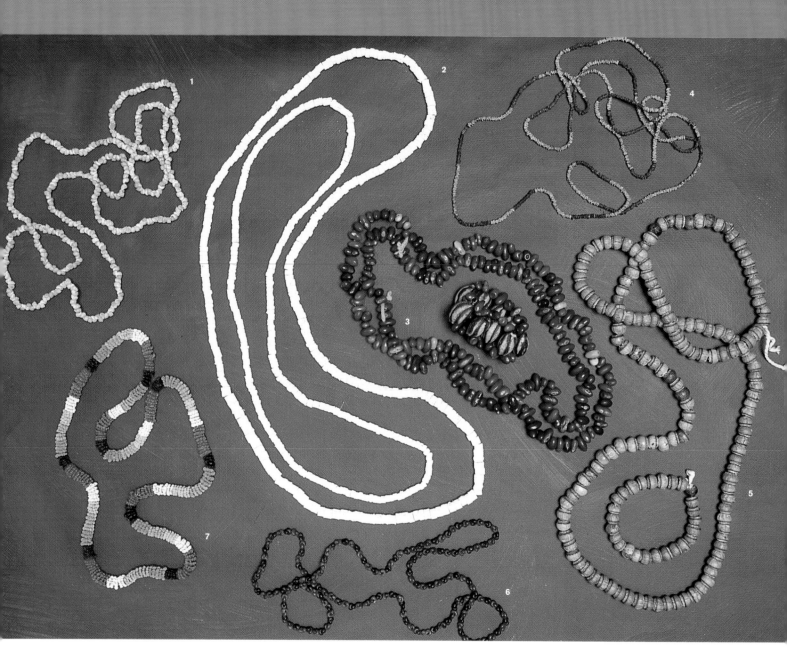

1

Beverly Barupa
Anbara Burarra
Maningrida,
Northern Territory
Necklace, 2001
155cm circumference
Snail shells (*Pleuropoma
sp.*) threaded on
fishing line

2

Philomena Wilson
Anbara Burarra
Maningrida,
Northern Territory
Necklaces, 2000
100cm and 130cm
circumference
Shark vertebrae
(*Carcharhinus sp.*)

3

Daisy Kanari
Pitjantjatjara
Kalka,
South Australia
Necklaces and Bracelet,
2001
65cm and 15cm
circumference
Necklace–Bat-winged
coral seeds (*Erythrina
verspertilio*) threaded on
yellow wool
Bracelet–Bat-winged
coral seeds (*Erythrina
verspertilio*) and branded
gum fruits (*Corymbia
opaca*) threaded on
black elastic

4

Anna Malibirr
Ganalbingu
Gapuwiyak,
Northern Territory
Necklaces, 2000
86cm and 87cm
circumference
Crotalaria goreensis
seeds threaded on
fishing line

5

Duncan Lynch
Arrernte
Ltyentye Apurte
(Santa Teresa),
Northern Territory
Necklace and Bracelet,
2001
136cm and 20cm
circumference
Gum tree fruits
(*Eucalyptus oxymitra*)
threaded on string

6

**Linda Minawala
Bidingal**
Ritharrngu
Gapuwiyak,
Northern Territory
Necklace, 1997
110cm circumference
Kapok seeds
(*Cochlospermum faseri*)
threaded on fishing line

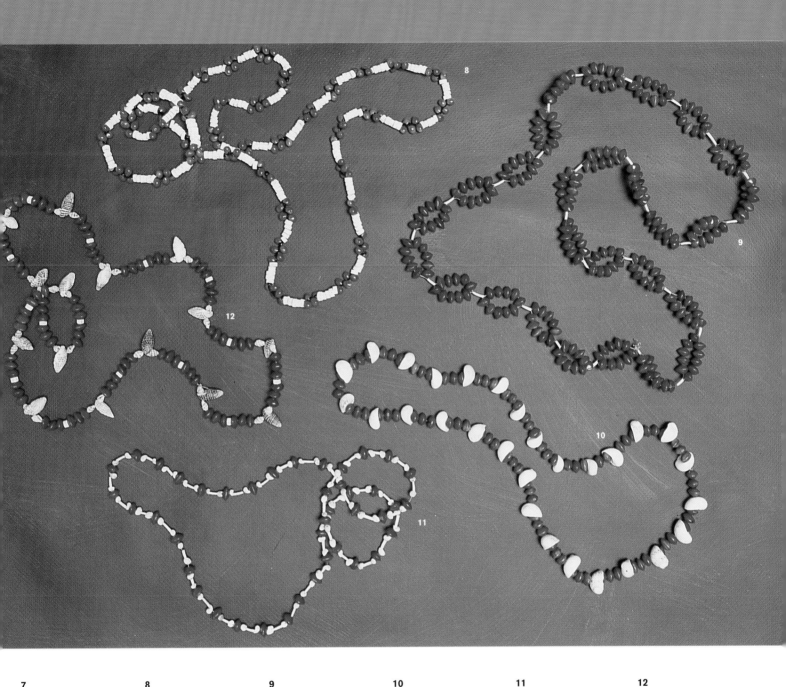

7

Eileen Bloomfield
Arrernte
Ltyentye Apurte
(Santa Teresa),
Northern Territory
Necklace, 1996
88cm circumference
Acrylic painted gum
operculums (*Eucalyptus torquata*) threaded on
black cotton

8

Margaret Likanbirriwuy
Djambarrpuyungu
Elcho Island,
Northern Territory
Necklace, 2000
121cm circumference
Crab eye seeds (*Abrus precatorius*), shark
vertebrae (*Carcharhinus sp.*) threaded on
fishing line

9

Elsie Marmanga
Burarra
Maningrida,
Northern Territory
Necklace, 2001
112cm circumference
Red bead tree seeds
(*Adenanthera pavonina*),
tusk shells (*Dentalium sp.*) threaded on
fishing line

10

Mabel Anka-anaburra
Burarra
Maningrida,
Northern Territory
Necklace, 2000
87cm circumference
Red bead tree seeds
(*Adenanthera pavonina*)
and shells (*Nerita undata*)
threaded on fishing line

11

Elsie Marmanga
Burarra
Maningrida,
Northern Territory
Necklace, 2001
85cm circumference
Red bead tree seeds
(*Adenanthera pavonina*),
necklace shells (*Clithon oualaniensis*), tusk shells
(*Dentalium sp.*) threaded
on fishing line

12

Mabel Anka-anaburra
Burarra
Maningrida,
Northern Territory
Necklace, 2000
88cm circumference
Red bead tree seeds
(*Adenanthera pavonina*),
shark vertebrae
(*Carcharhinus sp.*), dove
shells (*Euplica scripta*),
shells (*Clypeomorous bifasciata*) threaded on
fishing line

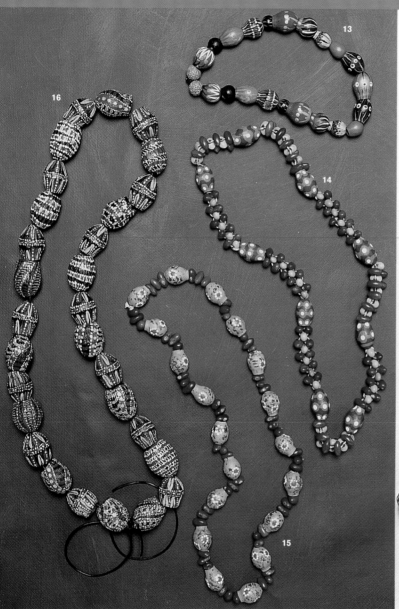

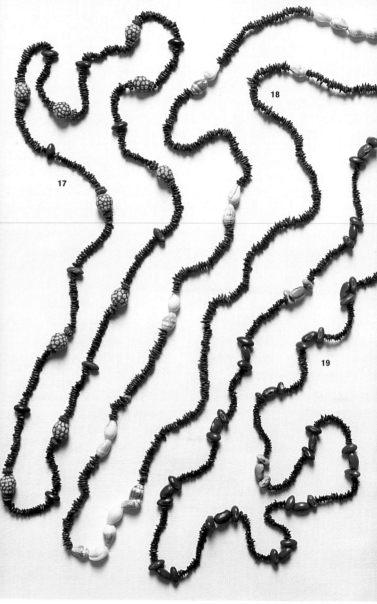

13

Joy McArthur
Naanyatjarra
Blackstone,
Western Australia
Necklace, 2001
44cm circumference
Acrylic painted gum fruits
(*Corymbia opaca*) and
Quandong seeds
(*Santalum acuminatum*)
threaded on black elastic

14

Martha Palmer
Arrernte
Ltyentye Apurte
(Santa Teresa),
Northern Territory
Necklace, 2001
82cm circumference
Acrylic painted gum fruits
(*Corymbia opaca*), bat-
winged coral seeds
(*Erythrina verspertilio*)
threaded on string

15

Martha Palmer
Arrernte
Ltyentye Apurte
(Santa Teresa),
Northern Territory
Necklace, 2001
88cm circumference
Acrylic painted gum fruits
(*Corymbia opaca*), bat-
winged coral seeds
(*Erythrina verspertilio*)
threaded on string

16

T. Kunmanara
Pitjantjatjara
Ernabella,
South Australia
Necklace, 2001
105cm circumference
Acrylic painted gum fruits
(*Corymbia ficifolia* or *C.
calophylla*) threaded
on leather

17

Leonie Campbell
Alice Springs,
Northern Territory
Necklace, 2001
130cm circumference
Small dark seeds (*Cassia
sp.* or *Acacia sp.*), acrylic
painted gum fruits
(*Corymbia opaca*), bat-
winged coral seeds
(*Erythrina verspertilio*)
and gum operculums
(*Eucaluptus sp.*) threaded
on dental floss

18

Mary Muyungu
(deceased)
Gälpu
Elcho Island,
Northern Territory
Necklace, 1998
148cm circumference
Coffee bush seeds
(*Leucaena leucocephala*),
dove shells (*Pyrene
punctata*) threaded on
fishing line

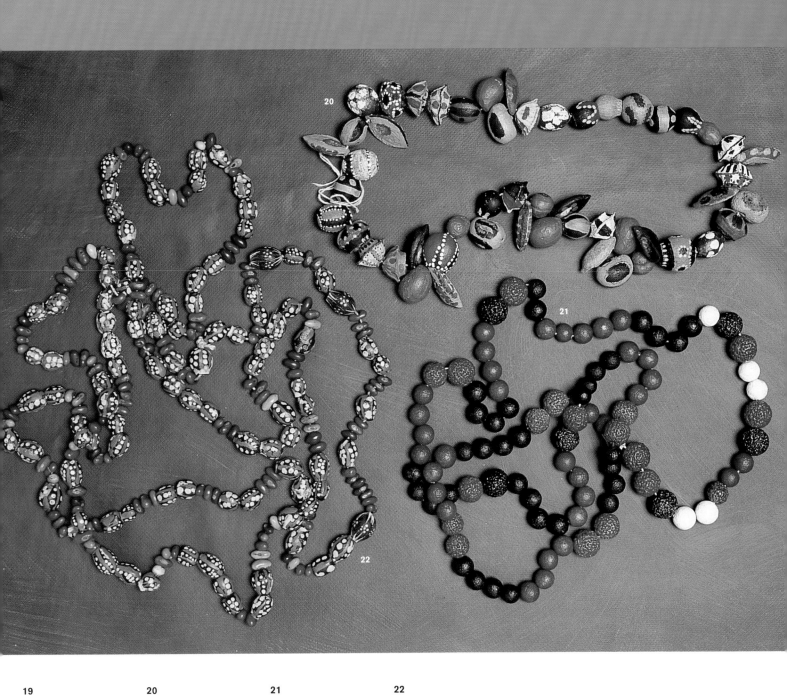

19

Leonie Campbell
Alice Springs,
Northern Territory
Necklace, 2001
154cm circumference
Small dark seeds (*Cassia sp.* or *Acacia sp.*) with red and yellow bat-winged coral seeds (*Erythrina verspertilio*) threaded on dental floss

20

Eva Napanangka Kelly
Warlpiri
Tennant Creek,
Northern Territory
Necklace, 1999
90cm circumference
Acrylic painted gum fruits (*Eucalyptus pachyphylla, Corymbia chippendaliea* or *sphaerica*), hakea pods (*Hakea macrophylla*) and red mallee operculums (*Eucalyptus socialis*) threaded on yellow wool

21

Betty West
Naanyatjarra
Warburton,
Western Australia
Necklace, 2001
165cm circumference
Acrylic painted Quandong (*Santalum acuminatum*) and sandalwood seeds (*Santalum spicatum*) threaded on string

22

Eileen Watson
Pitjantjatjara
Wingellina,
Western Australia
Necklace, 2001
308cm circumference
Acrylic painted gum fruits (*Corymbia opaca*), bat-winged coral seeds (*Erythrina verspertilio*) threaded on string

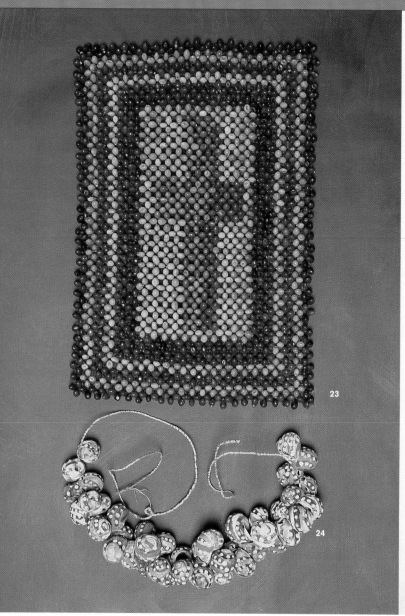

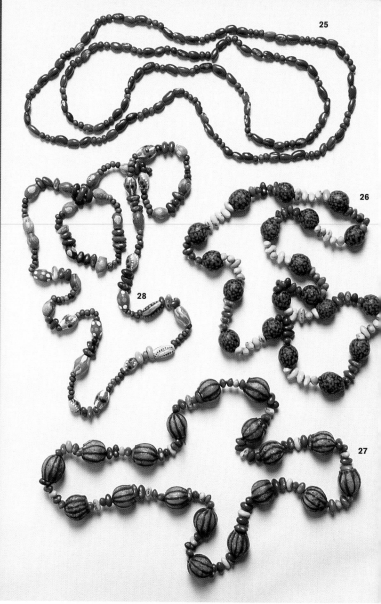

23

Maudie Raggett
Hermannsburg,
Northern Territory
Mat, 2001
45 x 30cm
Bat-winged coral seeds
(*Erythrina verspertilio*)
threaded on red wool

24

Lena Kuriniya
Ndjébbana
Maningrida,
Northern Territory
Rattle, 2000
130cm long
45 x 7 x 6mm
Ochre painted snail shells
(*Xanthomelon janellei* or
X. pachystylum) threaded
on hand-spun Kurrajong
(*Brachychiton
megaphyllus*) string

25

Cora Campbell
Luritja
Hermannsburg,
Northern Territory
Necklaces, 2001
100cm and 82cm
circumference
Bat-winged coral seeds
(*Erythrina verspertilio*)
and *nyiṯu* (*Stylobasium
spathulatum*) seeds
threaded on string

26

Agnes Petrick
Luritja
Harts Range (Atitjere),
Northern Territory
Necklace, 2001
124cm circumference
Acrylic painted fruits
(*Corymbia chippendaliea
or sphaerica*) and bat-
winged coral seeds
(*Erythrina verspertilio*)
threaded on doubled
red wool

27

Agnes Petrick
Luritja
Harts Range (Atitjere),
Northern Territory
Necklace, 2001
118cm circumference
Branded gum fruits
(*Corymbia chippendaliea
or sphaerica*) and bat-
winged coral seeds
(*Erythrina verspertilio*)
threaded on black wool

28

Bessie Liddle
Luritja
Iltiltjari (Middleton Ponds),
Northern Territory
Necklace, 2001
152cm circumference
Acrylic painted gum fruits
(*Corymbia opaca*), bat-
winged coral seeds,
(*Erythrina verspertilio*)
and *nyiṯu* seeds
(*Stylobasium
spathulatum*) threaded on
pale blue wool

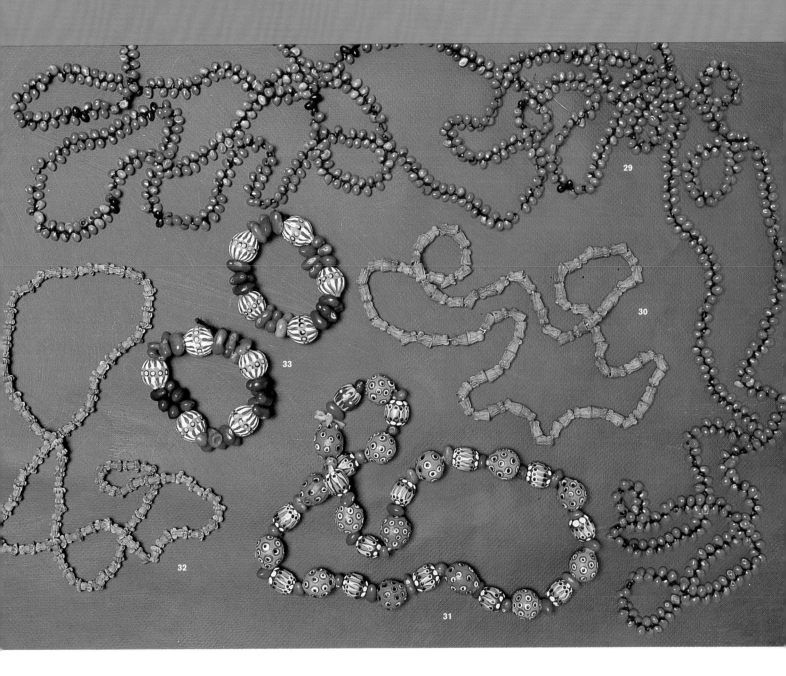

29

Nancy Walinyinawuy Guyula
Djambarrpuyungu
Gapuwiyak,
Northern Territory
Necklace, 1997
415cm circumference
Crab eye seeds (*Abrus precatorius*) threaded on fishing line

30

Duncan Lynch
Arrernte
Ltyentye Apurte (Santa Teresa),
Northern Territory
Necklace, 2001
100cm circumference
Immature gum fruits and operculums (*Eucalyptus torquata*) threaded on sewing thread

31

Kangitja Mervin
Pitjantjatjara
Watarru,
South Australia
Necklace, 2001
125cm circumference
Acrylic painted gum fruits (*Corymbia opaca*),
wooden beads and bat-winged coral seeds (*Erythrina verspertilio*) threaded on white wool

32

Duncan Lynch
Arrernte
Ltyentye Apurte
(Santa Teresa),
Northern Territory
Necklaces, 2001
105cm circumference
Immature gum fruits and operculums (*Eucalyptus torquata*) threaded on sewing thread

33

Muwitja Minyintiri
Pitjantjatjara
Watarru,
South Australia
Bracelets, 2001
18cm circumference each
Acrylic painted gum fruits (*Corymbia opaca*) and bat-winged coral seeds (*Erythrina verspertilio*) threaded on black elastic

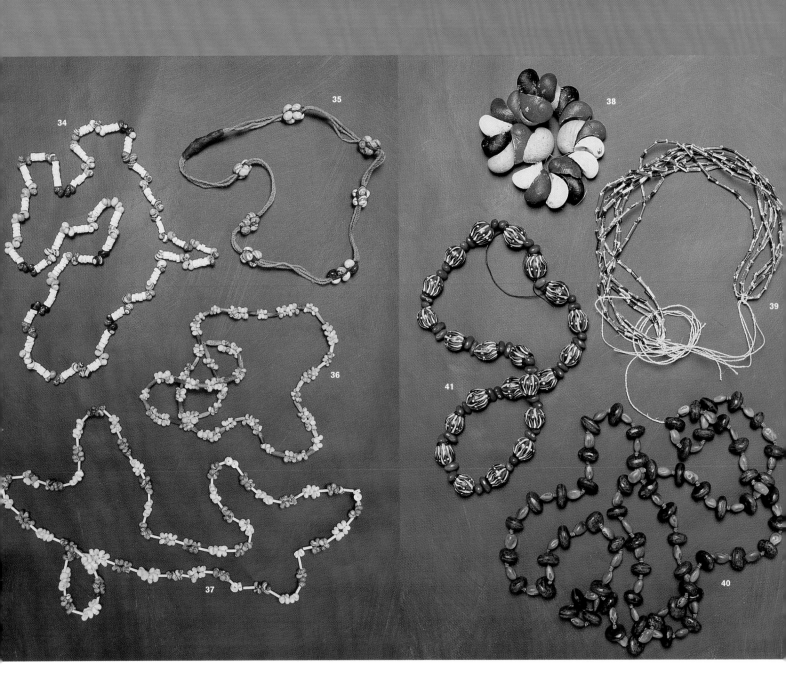

34

Margaret Likanbirriwuy
Djambarrpuyung,
Elcho Island,
Northern Territory
Necklace, 2000
114cm circumference
Necklace shells (*Clithon
oualaniensis*), shark
vertebrae (*Carcharhinus
sp.*) threaded on
fishing line

35

Gulumbu Yunupingu
Gumatj
Yirrkala,
Northern Territory
Necklace, 2001
72cm circumference
Necklace shells (*Clithon
oualaniensis*), beeswax
threaded on Kurrajong
(*Brachychiton
megaphyllus*)
hand-spun string

36

Celia Marbin
Burarra
Maningrida,
Northern Territory
Necklace, 2001
90cm circumference
Necklace shells (*Clithon
oualaniensis*), shells
(*Isanda coronata*), crab
legs (*Leucosia sp.*)
threaded on fishing line

37

**Laurie
Bayamarrawunga**
Nakarra
Maningrida,
Northern Territory
Necklace, 2001
138cm circumference
Necklace shells (*Clithon
oualaniensis*), shells
(*Monodonta labio,
Clanculus denticulatus,
Neritina violacea, Nerita
undata*), plastic tubing
threaded on fishing line

38

Lucy Ashley
Wagilag
Gapuwiyak,
Northern Territory
Dog Collar, 2001
40cm circumference
Acrylic painted snail
shells (*Xanthomelon
janellei or X.
pachystylum*) threaded
on fishing line

39

Lucy Ashley
Wagilag and
Anna Malibirr
Ganalbingu
Gapuwiyak,
Northern Territory
Necklace, 2000
125cm circumference
Acrylic painted grass
stems (*Leptoehloa fasca*)
threaded on Kurrajong
(*Brachychiton
megaphyllus*)
hand-spun string

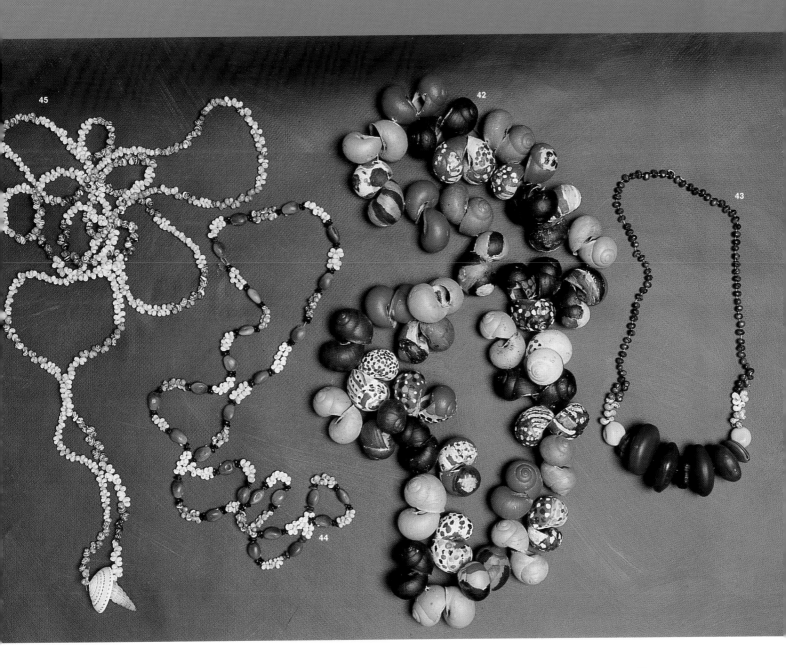

40

Lucille Wilfred
Ritharrngu
Walker River,
Northern Territory
Necklace, 2000
198cm circumference
Canavalia rosea, Mucuna sp., Acacia sp. seeds
threaded on fishing line

41

Alison M. Carroll
Pitjantjatjara
Ernabella,
South Australia
Necklace, 2001
88cm circumference
Acrylic painted gum fruits
(*Corymbia chippendaliea or sphaerica*) and bat-winged coral seeds
(*Erythrina verspertilio*)
threaded on leather

42

Lucy Ashley
Wagilag and
Anna Malibirr
Ganalbingu
Gapuwiyak,
Northern Territory
Necklace, 1999
126cm circumference
Acyrlic painted snail
shells (*Xanthomelon janellei or X. pachystylum*) threaded on
fishing line

43

Merrkiyawuy Ganambarr
Dätiwuy
Yirrkala,
Northern Territory
Necklace, 2001
65cm circumference
Necklace shells (*Clithon oualaniensis*), matchbox
seeds (*Entada phaseoloides*), big black
seeds (*Mucuna gigantea*),
grey seeds (*Caesalpinia bonduc*), crab eye seeds
(*Abrus precatorius*) and
Mucuna sp. threaded on
dental floss

44

Celia Marbin
Burarra
Maningrida,
Northern Territory
Necklace, 2000
128cm circumference
Canavalia rosea, Acacia sp. seeds, necklace shells
(*Clithon oualaniensis*)
threaded on fishing line

45

Barbara Rruwayi
Waramirri
Elcho Island,
Northern Territory
Necklace, 2000
250cm circumference
Necklace shells (*Clithon oualaniensis*), sundial
shell (*Architectonica perspectiva*), shell
(*Cerithidea anticipata*)
threaded on fishing line

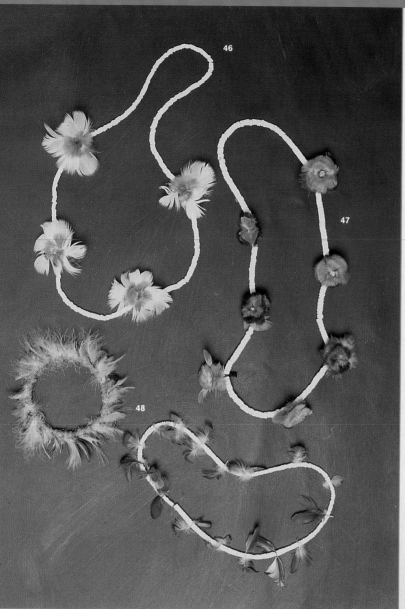

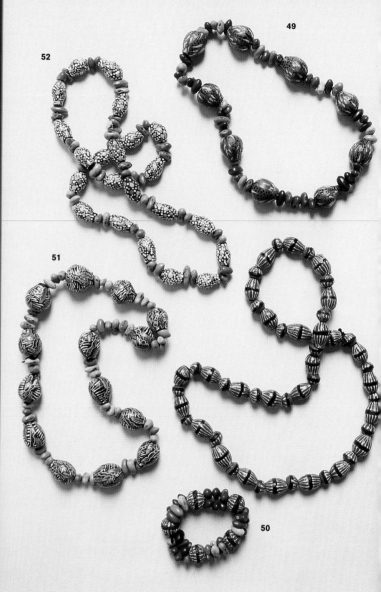

46

Rose Mamuniny #2
Gälpu
Elcho Island,
Northern Territory
Necklace, 2001
70cm circumference
Shark vertebrae
(*Carcharhinus sp.*),
red-collared lorikeet
feathers (*Trichoglossus
rubritorquis*), sulphur-
crested cockatoo feathers
(*Cacatua galerita*)
threaded on fishing line

47

Rose Mamuniny #2
Gälpu
Elcho Island,
Northern Territory
Necklace, 2001
76cm circumference
Necklace–Shark
vertebrae (*Carcharhinus
sp.*), red-winged parrot
feathers (*Aprosmictus
erythropterus*) threaded
on fishing line

48

Rose Mamuniny #2
Gälpu
Elcho Island,
Northern Territory
Necklace and Bracelet,
2001, 50cm and 20cm
circumference
Necklace–Shark
vertebrae (*Carcharhinus
sp.*), red-collared lorikeet
(*Trichoglossus
rubritorquis*) feathers
threaded on fishing line,
Bracelet–Red-collared
lorikeet (*Trichoglossus
rubritorquis*) feathers
bound by hand-spun
string

49

Judy Davis
Pitjantjatjara
Watinuma,
South Australia
Necklace, 2001
60cm circumference
Acrylic painted gum fruits
(*Corymbia opaca sp.*) and
bat-winged coral seeds
(*Erythrina verspertilio*)
threaded on black elastic

50

Judy Davis
Pitjantjatjara
Watinuma,
South Australia
Necklace and Bracelet,
2001
84cm and 18cm
circumference
Acrylic painted gum fruits
(*Corymbia opaca*),
Quandong (*Santalum
acuminatum*) and bat-
winged coral seeds
(*Erythrina verspertilio*)
threaded on black elastic

51

Diane Brown
Pitjantjatjara
Watinuma,
South Australia
Necklace, 2000
68cm circumference
Acrylic painted gum fruits
(*Corymbia opaca sp.*) and
bat-winged coral seeds
(*Erythrina verspertilio*)
threaded on black elastic

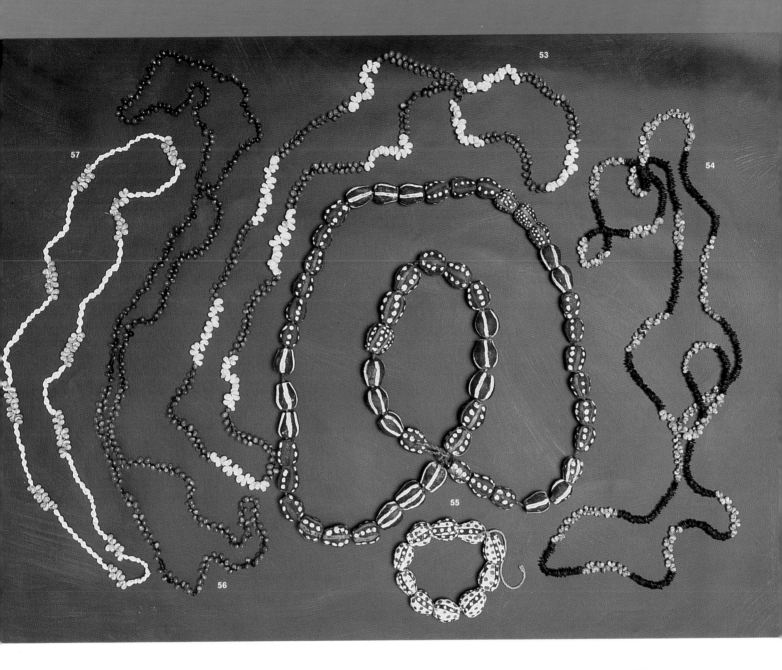

52

Joanne Ken
Pitjantjatjara
Alice Springs,
Northern Territory
Necklace, 2001
82cm circumference
Acrylic painted gum fruits
(*Corymbia opaca sp.*) and
bat-winged coral seeds
(*Erythrina verspertilio*)
threaded on black elastic

53

**Margaret
WurrayWurray
Gondarra**
Golumala
Elcho Island,
Northern Territory
Necklace, 2001
184cm circumference
Crab eye seeds (*Abrus
precatorius*), shells (*Nerita
undata*) threaded on
fishing line

54

Mary Muyungu
(deceased)
Gälpu
Elcho Island,
Northern Territory
Necklace, 1998
212 cm circumference
Coffee bush seeds
(*Leucaena leucocephala*),
necklace shells (*Clithon
oualaniensis*) threaded on
fishing line

55

Lena Kuriniya
Ndjébbana
Maningrida,
Northern Territory
Necklace and Bracelet,
2000
112cm and 25cm
circumference
Ochre painted gum fruits
(*Corymbia Ferruginea*)
threaded on string

56

**Margaret Ngangiyawuy
Guyula**
Djambarrpuyungu
Gapuwiyak,
Northern Territory
Necklace, 1997
180cm circumference
Crab eye seeds (*Abrus
precatorius*) threaded on
fishing line

57

**Mary Wulumduna
Gurruwiwi**
Gälpu
Ski Beach,
Northern Territory
Necklace, 2000
123cm circumference
Necklace shells (*Clithon
oualaniensis*), white dove
shells (*Euplica scripta*)
threaded on fishing line

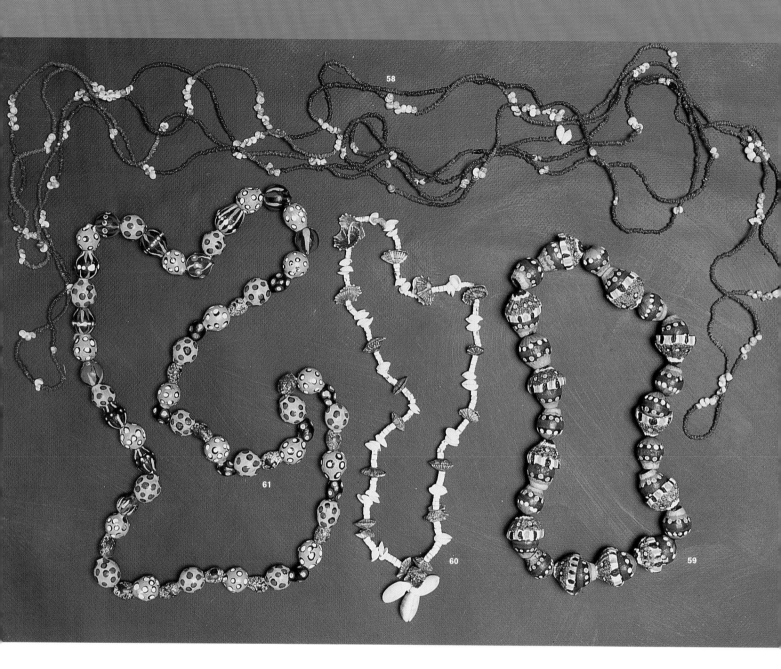

58

**Mary
Djarryjarrminypuy
Birritjiama**
Ḻiyagalawumirr
Gapuwiyak,
Northern Territory
Necklace, 1998
320cm and 280cm
circumference
Crotalaria goreensis
seeds, necklace shells
(*Clithon oualaniensis*)
threaded on fishing line

59

Atipalku Intjalki
Pitjantjatjara
Ernabella,
South Australia
Necklace, 1996
65cm circumference
Acrylic painted gum fruits
(*Corymbia chippendaliea
or sphaerica*) and gum
operculums (*Eucalyptus
kingsmillii or youngianyu*)
threaded on string

60

Maliny Mununggurr
Djapu
Yirrkala,
Northern Territory
Pendant, 2001
72cm circumference
Shark vertebrae
(*Carcharhinus sp.*), shells
(*Fragum sp.*), bubble
shells (*Aliculastrum
cylindricum*), cowrie
shells (*Cypraea errones*),
shells (*Siphonara atra*)
threaded on fishing line

61

Kangitja Mervin
Pitjantjatjara
Watarru,
South Australia
Necklace, 2001
85cm circumference
Acrylic painted gum fruits
(*Corymbia opaca*)
threaded on string

62

**Nancy Walinyinawuy
Guyula**
Djambarrpuyungu
Gapuwiyak,
Northern Territory
Necklace, 1997
145cm circumference
Crab eye seeds (*Abrus
precatorius*), seeds
(*Acacia sp.*) threaded
on fishing line

63

Nungalka Wirtima
Pitjantjatjara
Ernabella,
South Australia
Necklace, 1999
65cm circumference
Acrylic painted gum fruits
(*Corymbia opaca*) and
bat-winged coral seeds
(*Erythrina verspertilio*)
threaded on violet wool

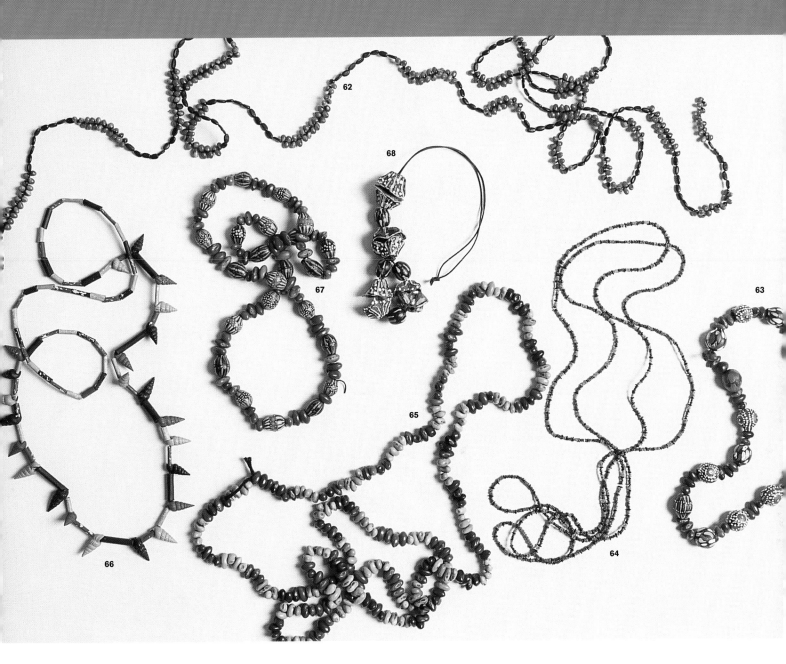

64

Rhonda Wurruypum Guyula
Djambarrpuyungu
Gapuwiyak,
Northern Territory
Necklaces, 2000
110cm and 135cm
circumference
Crotalaria goreensis
seeds, seeds (*Acacia sp.*)
threaded on fishing line

65

Muwitja Brumby
Pitjantjatjara
Ernabella,
South Australia
Necklace, 2001
205cm circumference
Bat-winged coral seeds
(*Erythrina verspertilio*)
threaded on brown wool

66

Lucy Ashley
Wagilag
Gapuwiyak,
Northern Territory
Necklace, 2001
125cm circumference
Acrylic painted pipe tree
wood (*Scaevola taccada*),
shell threaded on
fishing line

67

Alison M. Carroll
Pitjantjatjara
Ernabella,
South Australia
Necklace, 2001
95cm circumference
Acrylic painted gum fruits
(*Corymbia opaca*) and
bat-winged coral seeds
(*Erythrina verspertilio*)
threaded on leather

68

Esther McKenzie
Pitjantjatjara
Ernabella,
South Australia
Pendant, 1997
37cm circumference,
pendant 13 x 6 x 3cm
Acrylic painted gum fruits
(*Corymbia opaca*) and
gum operculums threaded
on leather

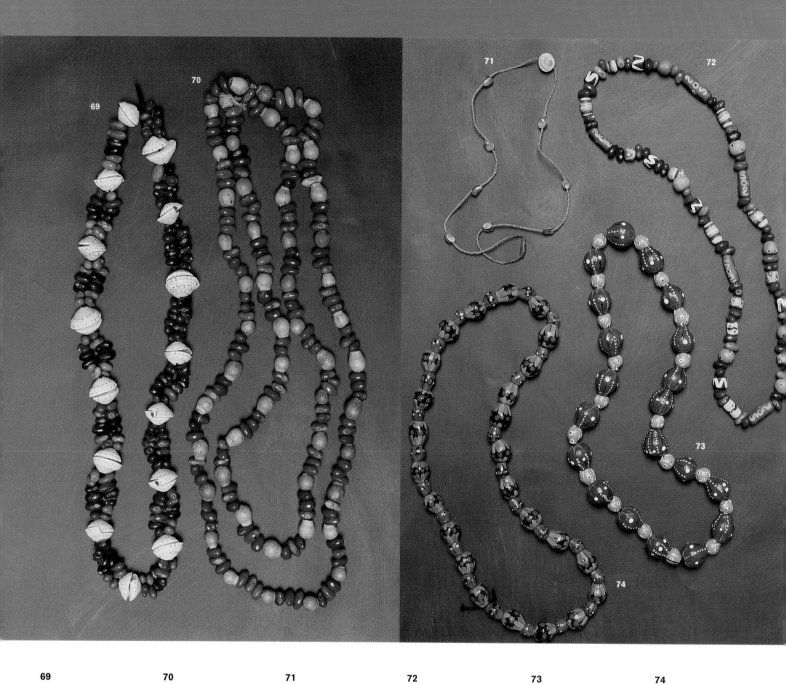

69

Nellie Nambayana
Burarra
Maningrida,
Northern Territory
Necklace, 2000
98cm circumference
Bat-winged coral seeds
(*Erythrina verspertilio*),
sundial shell
(*Architectonica
perspectiva*) threaded
on fishing line

70

**Queenie N.M.
Adamson**
Pitjantjatjara
Amata,
South Australia
Necklace, 2001
200cm circumference
Unpainted gum fruits
(*Corymbia opaca*) and
bat-winged coral seeds
(*Erythrina verspertilio*)
threaded on string

71

**Brownyn Wuyuwa
Mununggurr**
Djapu
Ski Beach,
Northern Territory
Necklace, 2001
72cm circumference
Blue operculums
(*Astralium stellare*), green
operculum (*Turbo
squamosus*), beeswax
threaded on fishing line

72

Sabrina Ungwanaka
Luritja
Hermannsburg,
Northern Territory
Necklace, 2001
92cm circumference
Handmade fired
terracotta clay beads
painted with underglazes
threaded on string

73

Yangkuyi Yakiti
Pitjantjatjara
Ernabella,
South Australia
Necklace, 2001
84cm circumference
Acrylic painted gum fruits
(*Corymbia opaca*)
threaded on leather

74

Betty Munti
Pitjantjatjara
Amata,
South Australia
Necklace, 2001
88cm circumference
Acrylic painted gum fruits
(*Corymbia opaca*)
threaded on black elastic

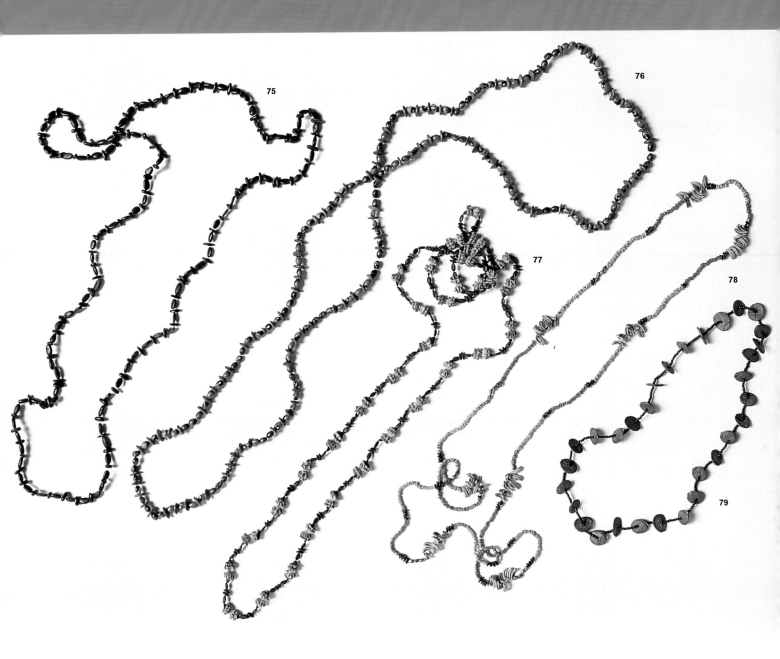

75

Mary Djupuduwuy Guyula
Djambarrpuyungu
Gapuwiyak,
Northern Territory
Necklace, 1996
120cm circumference
Acacia sp. seeds
threaded on fishing line

76

Rose Wilfred
Wagilag
Walker River,
Northern Territory
Necklace, 2000
130cm circumference
Crab eye seeds (*Abrus precatorius*), yellow flame
tree seeds (*Cassia fistula*)
threaded on fishing line

77

Leonie Campbell
Alice Springs,
Northern Territory
Necklace, 1997
114cm circumference
Small black seeds
(*Cassia sp. or Acacia sp.*)
and gum operculums
(*Eucalyptus sp.*) threaded
on dental floss

78

Lucy Ashley
Wagilag
Gapuwiyak,
Northern Territory
Necklace, 1996
125cm circumference
Crotalaria goreensis
seeds, anthers (*Senna sp.*), seeds (*Acacia sp.*),
olive seeds (*Senna obtusifolia*) threaded
on fishing line

79

Kathy Nyinyipuwa Guyula
Djambarrpuyungu
Gapuwiyak,
Northern Territory
Necklace, 2000
56cm circumference
Ironwood seeds
(*Erythrophleum chlorostachys*), black
glass beads threaded
on fishing line

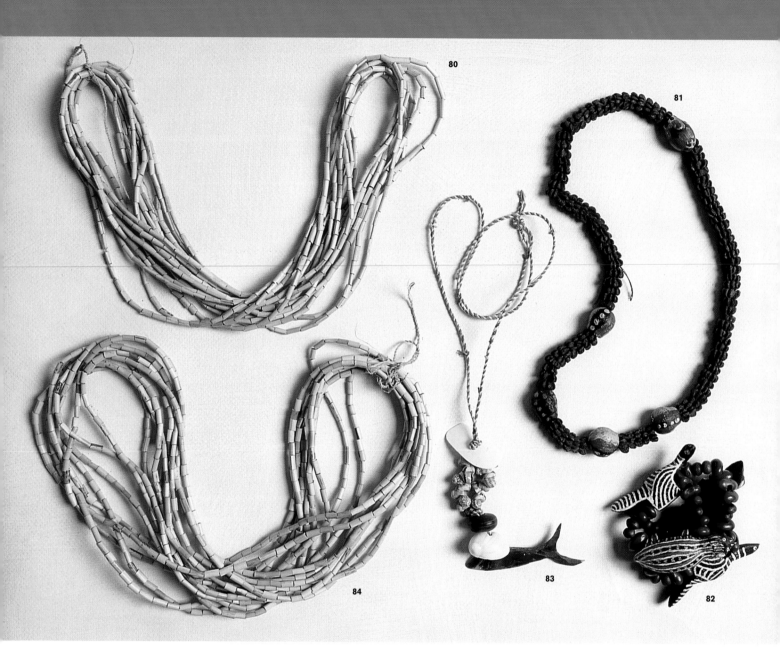

80

Mary Djupuduwuy Guyula
Djambarrpuyungu
Gapuwiyak,
Northern Territory
Necklace, 2001
41cm circumference
Grass stems (*Leptoehloa fasca*) threaded on hand-spun Kurrajong (*Brachychiton megaphyllus*) string

81

Cissy Riley
Yankunytjatjara
Indulkana,
South Australia
Necklace, 1998
65cm circumference
Acrylic painted gum fruits (*Corymbia opaca*) scented gum operculums (*Eucaluptus lesonefii*) threaded on black cotton

82

Niningka Lewis
Pitjantjatjara
Kalka,
South Australia
Bracelet, 1997
20cm circumference
Acrylic painted river red gum root carvings (*Eucaluptus camaldulensis*), bat-winged coral seeds (*Erythrina verspertilio*) and *nyitu* seeds (*Stylobasium spathulatum*) threaded on black elastic

83

Gulumbu Yunupingu
Gumatj
Yirrkala,
Northern Territory
Pendant, 2001
83cm circumference
Necklace shells (*Clithon oualaniensis*), moon snail shell (*Polinices mammilla*), cut scallop shell (*Amusium pleuronectes*), *Mucuna sp.*, cut tortoise shell threaded on hand-spun Kurrajong (*Brachychiton megaphyllus*) string

84

Mary Djupuduwuy Guyula
Djambarrpuyungu
Gapuwiyak,
Northern Territory
Necklace, 2001
40cm circumference
Grass stems (*Leptoehloa fasca*) threaded on hand-spun Kurrajong (*Brachychiton megaphyllus*) string

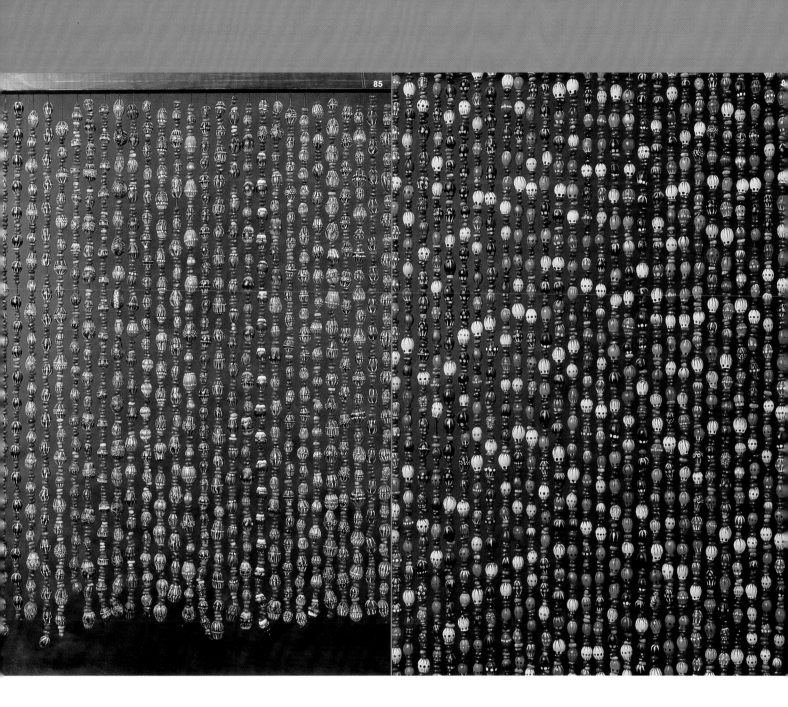

85

Daisy (Nyukana) Baker
Pitjantjatjara
Ernabella,
South Australia
Fly curtain, 2001
117 x 92cm
Acrylic painted gum fruits
(*Corymbia ficifolia or C. calophylla* with *C opaca* and *chippendaliea*), bat-winged coral seeds (*Erythrina verspertilio*) threaded on leather

86

Panjiti McKenzie
Pitjantjatjara
Ernabella,
South Australia
Fly curtain, 2001
220 x 99cm
Acrylic painted gum fruits
(*C opaca*) and bat-winged coral seeds (*Erythrina verspertilio*) threaded on leather

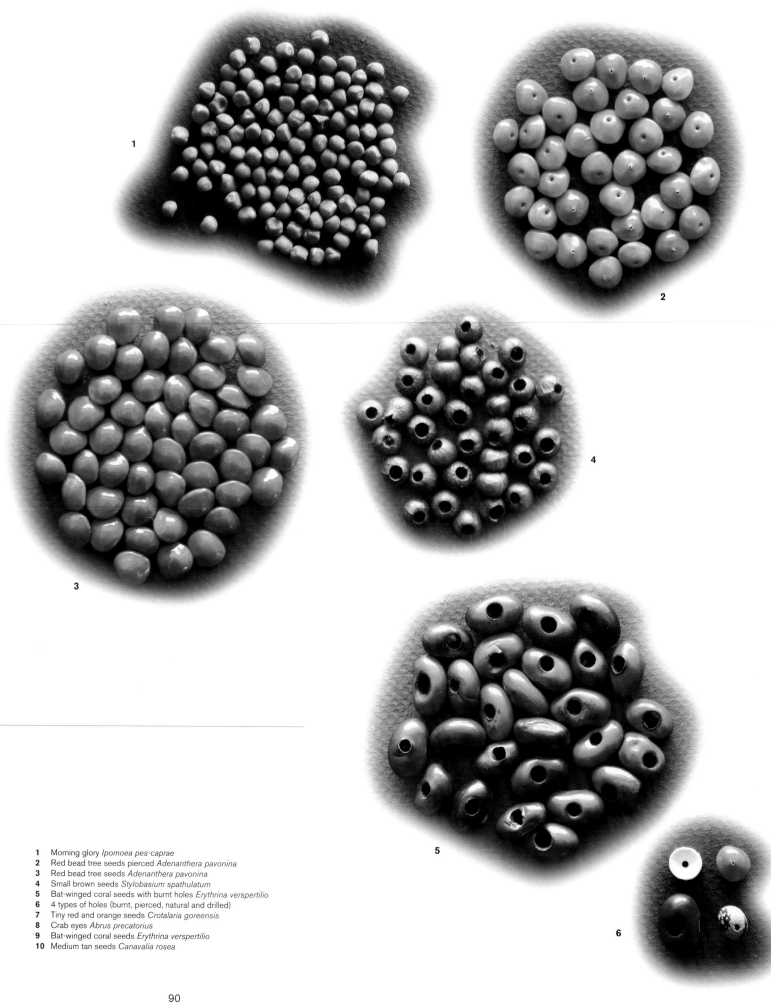

1 Morning glory *Ipomoea pes-caprae*
2 Red bead tree seeds pierced *Adenanthera pavonina*
3 Red bead tree seeds *Adenanthera pavonina*
4 Small brown seeds *Stylobasium spathulatum*
5 Bat-winged coral seeds with burnt holes *Erythrina verspertilio*
6 4 types of holes (burnt, pierced, natural and drilled)
7 Tiny red and orange seeds *Crotalaria goreensis*
8 Crab eyes *Abrus precatorius*
9 Bat-winged coral seeds *Erythrina verspertilio*
10 Medium tan seeds *Canavalia rosea*

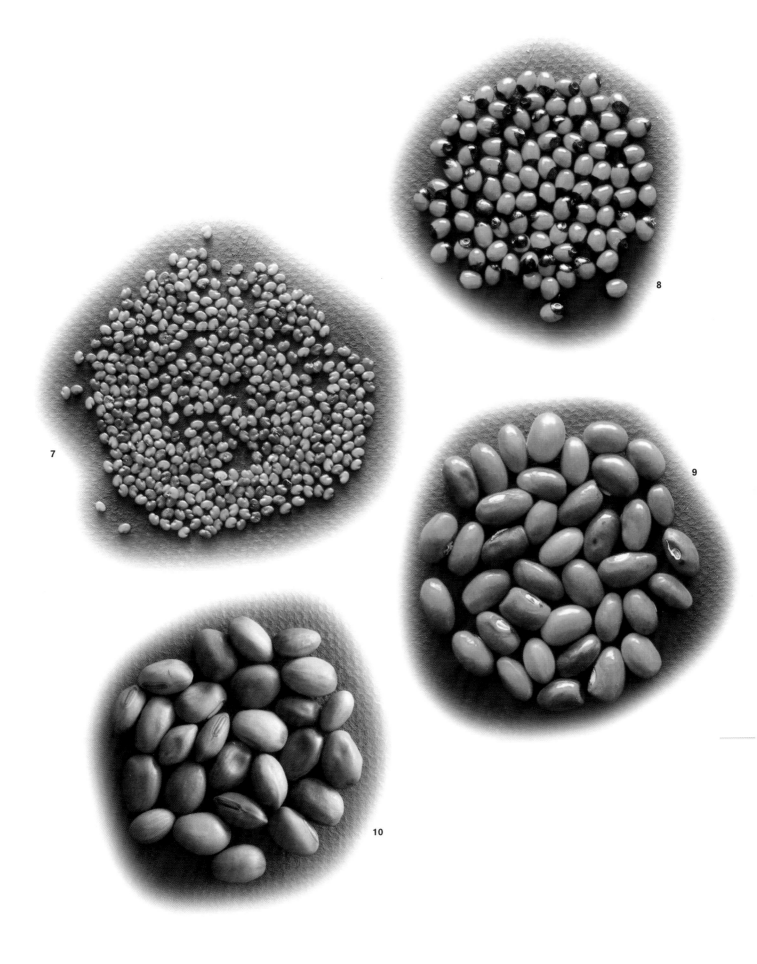

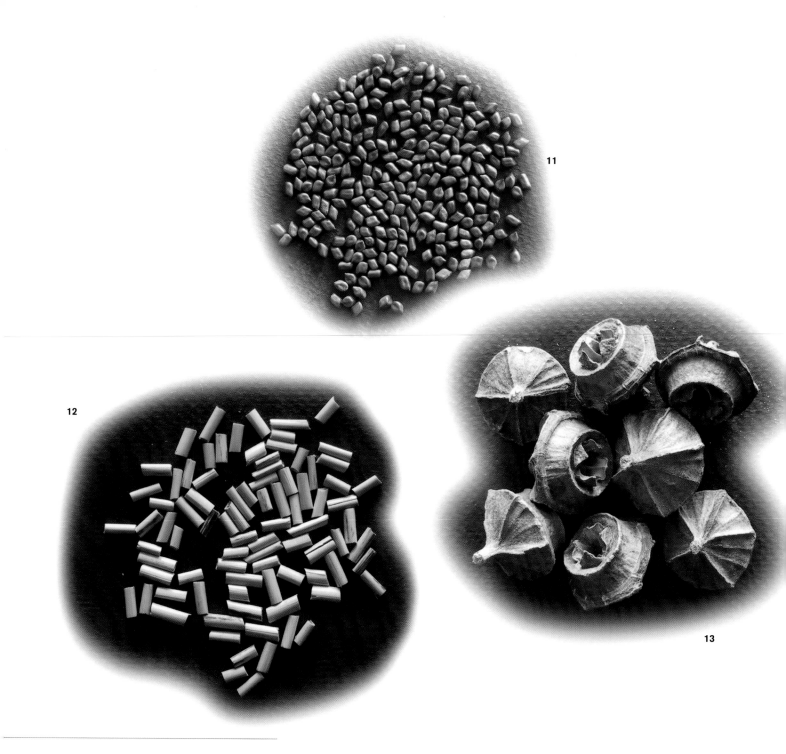

11

12

13

11 Small olive seeds *Senna obtusifolia*
12 Grass stems *Leptoehloa fasca*
13 Red mallee *Eucalyptus pachyphylla*
14 Coffee bush *Leucaena leucocephala*
15 Ironwood *Erythrophleum chlorostachys*
16 Kapok *Cochlospermum faseri*
17 Quondong *Santalum acuminatum*
18 Hakea pods *Hakea macrophylla*
19 Operculums *Eucalyptus lesonesii*

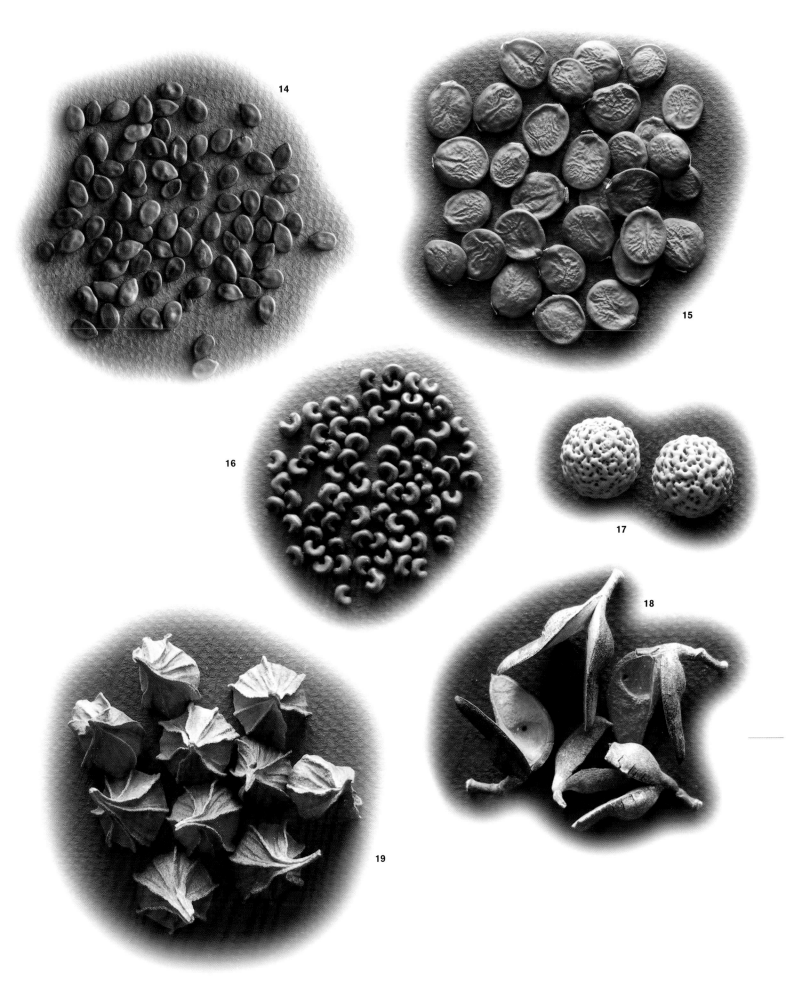

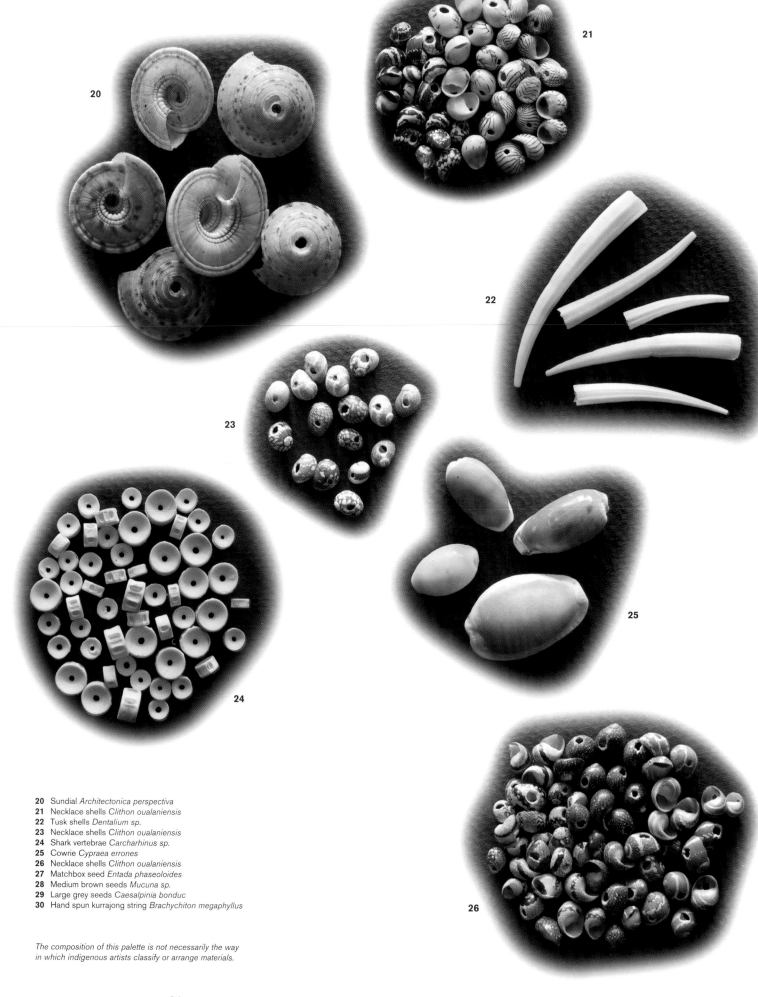

20 Sundial *Architectonica perspectiva*
21 Necklace shells *Clithon oualaniensis*
22 Tusk shells *Dentalium sp.*
23 Necklace shells *Clithon oualaniensis*
24 Shark vertebrae *Carcharhinus sp.*
25 Cowrie *Cypraea errones*
26 Necklace shells *Clithon oualaniensis*
27 Matchbox seed *Entada phaseoloides*
28 Medium brown seeds *Mucuna sp.*
29 Large grey seeds *Caesalpinia bonduc*
30 Hand spun kurrajong string *Brachychiton megaphyllus*

*The composition of this palette is not necessarily the way
in which indigenous artists classify or arrange materials.*

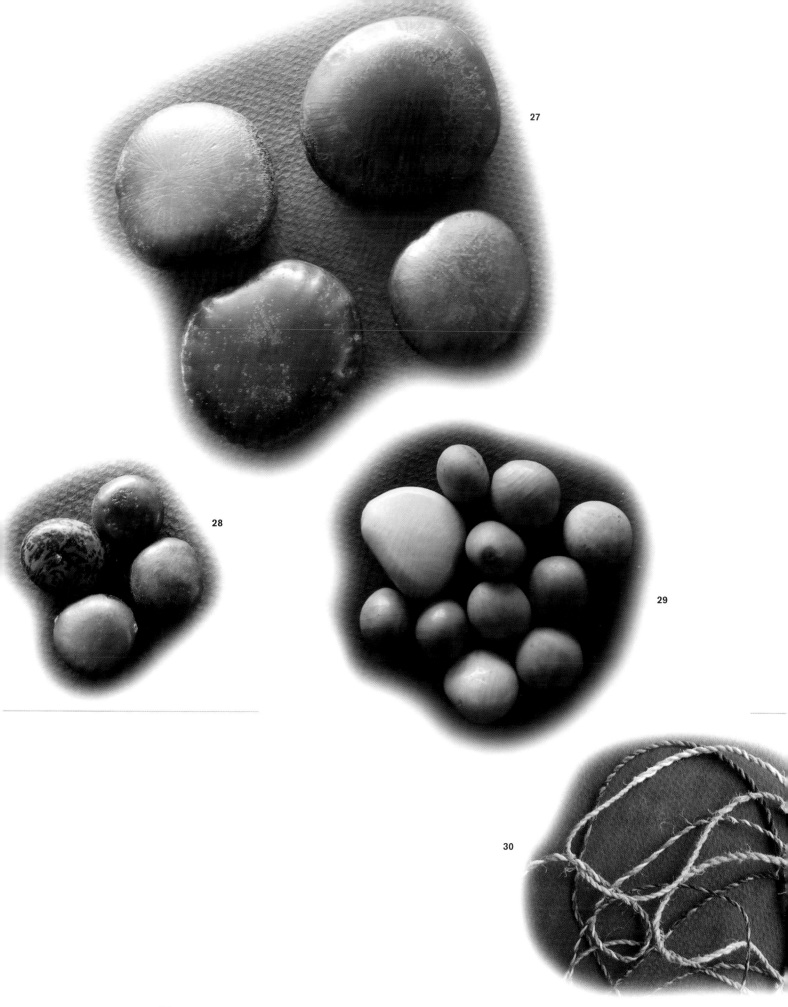

27

28

29

30

ACKNOWLEDGEMENTS

Art on a String has been a collaborative project with many people providing valuable assistance. The curators of the exhibition would like thank all of those who have helped make the idea a reality. First of all, thanks to all the artists involved in the exhibition and the many individuals who have made threaded objects that could not be included in this exhibition. The staff at Object have played an integral role, especially Brian Parkes and the exhibitions team; Sarah Wilson, Andrew Stevens and Darryl Chapman as well as the interns for this exhibition; Meredith Hughes, Kiri Soede and Lorena Galvani.

In Arnhem Land many have been of assistance with special thanks to; Richard and Cherie West, Christianne Keller, Fiona Salmon, Brenda Westley, Steve Westley, Will Stubbs, Gulumbu Yunupingu, Merrkiyawuy Ganambarr, Marrnyula Mununggurr, Nonggirrnga Marawili, Yilki Nunggumajba, Peter Datjin Burarrwanga, Priscilla Ganangarrpul Dhamarandji, Yvonne Dhawuratji Ganambarr, Caroline Bunhala Burarrwanga, Lucy Ashley, Florence Ashley.

In the Central Desert, many thanks to; Daisy (Nyukana) Baker, Alison M. Carroll, Leonie Campbell, Jacqueline Dawborn, Steve Fox, Alison French, Hilary Furlong, Helen Gordon, Susan Graham, Dora Haggie, Luke Hoffman, Anne-Marie May, Karina Menkhorst, Jock Morse, Liz Orr, Beverly Peacock, Gerard Rogers, Patsy Ross, Naomi Sharpe, Lisa Shaw, Tracy-Lee Smith, Gertrude Stotz, Kanitija (Nyuwara)Tapaya.

There has also been a group of professional people in areas who have assisted in translation, computing, cataloguing and material identification, thank you to; Frances Morphy, Keren Ruki, Tony Rodd, Glen Wightman, Ian Loch, and Ron Brooker.